IMAGES
of America

LIVONIA PRESERVED

GREENMEAD AND BEYOND

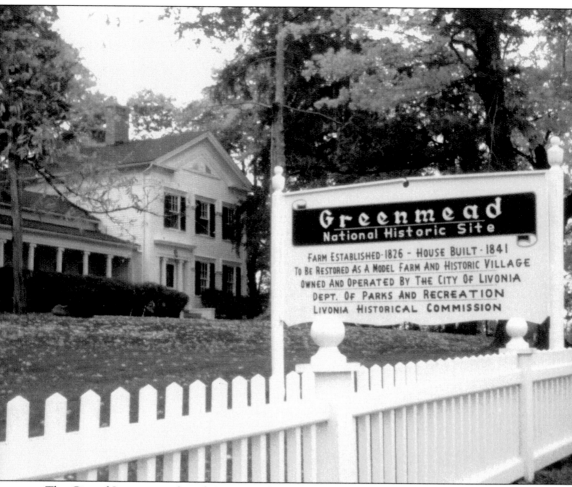

The City of Livonia purchased Greenmead in 1976. The property contained this 1841 Greek Revival house, a caretaker's cottage, a farmer's house, two carriage houses, two large barns, a few smaller outbuildings, and 103 acres of land. The Simmons-Hill House became a museum in September 1977. The Livonia Historical Village was established on the northeast section of the property and organized into two main areas: the 1850s buildings and the Newburg Intersection.

On the cover: Please see page 51. (Livonia Historical Commission.)

IMAGES
of America

LIVONIA PRESERVED

GREENMEAD AND BEYOND

Suzanne Daniel and Kathleen Glynn

ARCADIA
PUBLISHING

Published by Arcadia Publishing
Charleston, South Carolina

Printed in the United States of America

Library of Congress Catalog Card Number: 2006933273

For all general information contact Arcadia Publishing at:
Telephone 843-853-2070
Fax 843-853-0044
E-mail sales@arcadiapublishing.com
For customer service and orders:
Toll-Free 1-888-313-2665

Visit us on the Internet at www.arcadiapublishing.com

This book is dedicated to the many hardworking volunteers who have been integral to the Greenmead story. From Greenmead's beginnings to the present day, their dedicated participation has been critical to its success.

CONTENTS

ACKNOWLEDGMENTS

Many people have contributed in diverse ways to the creation of this book, beginning with Hon. Jack Engebretson, mayor of Livonia, who provided enthusiastic support from its inception.

We thank the many Livonia families who over the years have donated photographs, memorabilia, and information, especially the Briggs, Clemens, Dietrich, Hill, Hinbern, Kingsley, Ryder, Shaw, Simmons, and Wolfram families. Without their generosity, we would not have been able to assemble the personal stories that make Livonia's history and historic resources so rich and vibrant.

The images in this book are primarily from the collection of the Livonia Historical Commission at Greenmead and the files of the Livonia Historic Preservation Commission. Photographs of the buildings dating from the 1960s and 1970s were taken by Electra Stamelos, Edward Reid, Nick Mladjan, and Les Newcomer. Photographs depicting the moving of the buildings, the progress of restoration, and activities at Greenmead were taken by one of the authors, Suzanne Daniel. We thank both commissions for their support and encouragement during this project. We have used 14 images that appeared in the previous Arcadia book *Livonia* by David McGregor. Due to the limited number of early photographs of these buildings, it was necessary to repeat some from the Greenmead archive to adequately tell the story.

We also thank the professional staff at Greenmead—Marian Renaud, Linda Wiacek, Suzette Malamis, and Marcia Miller—who provided encouragement, advice, humor, and sometimes lunch during our months of working on the book. Roger Glynn provided computer support and editing assistance. Finally, we would like to thank Tamara Christie Glynn for her professional editorial skills and counsel, which helped shape the text into its final form.

We are grateful to all who helped bring this project to print.

INTRODUCTION

Meadow Brook Farm, later called Greenmead, has been an enduring part of Livonia's history ever since Joshua Simmons purchased the land in 1824. An early pioneer, Simmons was the third person to buy land in Livonia Township. The 160-acre farm eventually consisted of a Greek Revival farmhouse built in 1841, an 1829 barn, a later barn, a carriage house, a farmhand's house, and other small farm buildings, all of which remain on the Greenmead property today. The farmhand's house most likely replaced the original log house as the family home. Later still, Simmons constructed the beautiful Greek Revival home for his family. By hard work and perseverance, Joshua and Hannah Simmons carved a prosperous farm out of the wilderness—a farm that housed four generations of the Simmons family until the early 20th century.

Sherwin A. Hill, a prominent Detroit lawyer in the early 1900s, and his wife, Jean Boyd Hill, were city dwellers attracted to the peace and tranquility of rural Livonia Township. In 1920, on their way to nearby Meadowbrook Country Club, they noticed the old farm for sale and soon purchased it. The 80-year-old home needed some tender loving care, and the Hills undertook its restoration and repair. They made their home at Greenmead, which remained a working farm until Sherwin died in the early 1960s. Jean continued to live at her beloved Greenmead until her death in 1974. She recognized the importance of the property, including the number and quality of the extant farmstead buildings. She successfully submitted the farm for placement on the National Register of Historic Places.

For nearly 100 years after the early arrivals, Livonia remained a farming community with a few small crossroads villages: Newburg, Livonia Center, Elm, Stark, and Clarenceville. However, in the early 20th century, there were a few signs that times were changing. Horton's subdivision, the first of this type of development in Livonia, was built around 1915 between Ann Arbor Trail and Ann Arbor Road. In 1925, Coventry Gardens at Five Mile Road and Farmington Road, and Rosedale Gardens at Plymouth Road and Merriman Road were platted. These milestones marked the beginning of suburban development in Livonia. Growth continued, slow and steady, until Livonia became a city in 1950, after which the population exploded.

If one looks closely, many signs of Livonia's past are visible. During the 1960s and 1970s, the city developed rapidly, and many old structures were threatened with demolition to make way for new buildings. The Livonia Historical Society and the Livonia Historical Commission recognized the value of older structures as part of the area's heritage and organized an effort to save several of these historic assets. The two groups urged the city to purchase Quaker Acres, the one-acre site of a Society of Friends (Quaker) meetinghouse on Seven Mile Road west of Farmington Road. The meetinghouse had been converted to a residence when that group of Friends disbanded many years earlier. In the 1970s, when the bicentennial created renewed interest in America's history, several other important Livonia structures—the Shaw House, A. J. Geer Store, and Detroit United Railway Waiting Room—were moved to the Quaker Acres site.

In 1976, the City of Livonia purchased Greenmead farm from the Hill estate. The Livonia Historical Village was created on 10 acres of the 103-acre farm, and plans were made to preserve the Simmons-Hill House as a museum. The Quaker Acres buildings were relocated to the larger site at Greenmead.

In this book, the authors chronicle the buildings' journeys as they were moved to their new home at Greenmead. Other historic structures that were later relocated to Greenmead include the Newburg Church and Parsonage, the Kingsley House, the Bungalow, and the Newburg School. The historical village was developed to reflect two time periods: the 1850s, some 25 years after the original settlement; and the early 1920s, about 25 years before Livonia became a city.

When the Livonia Historic Preservation Ordinance was passed in 1976, several of the city's remaining early structures were officially designated as local historic resources. These properties include Henry Ford's Newburg Mill, the Wilson Barn, two former church buildings, four cemeteries, and several farmhouses that remain as private residences. The buildings reflect diverse architectural styles such as Greek Revival, Italianate, Gothic Revival, and Queen Anne.

In the 1980s, when the Alexander Blue House was in danger of demolition, the Livonia City Council voted to approve its relocation to Greenmead and establish it as an income-producing building. The house was moved adjacent to the village and restored. Many couples that exchange nuptials in Newburg Church in the historical village hold their wedding receptions at the nearby Alexander Blue House.

Greenmead is an enduring symbol of the American agricultural lifestyle. The story of Joshua and Hannah Simmons, like those of many other pioneer families, deserves to be preserved and retold. Greenmead pays tribute to Livonia's roots by showcasing the legacies of those early, hardworking families and provides a basis for future efforts to protect Livonia's historic treasures—not just at Greenmead but throughout the city.

Livonia Preserved: Greenmead and Beyond documents the Greenmead project's beginnings, its growth, and its evolution through the years. It also examines the other Livonia buildings and sites that are designated as historic resources. Their history comes alive through photographs and stories of the buildings, the sites, and the people who built them, lived in them, and loved them.

One

QUAKER ACRES

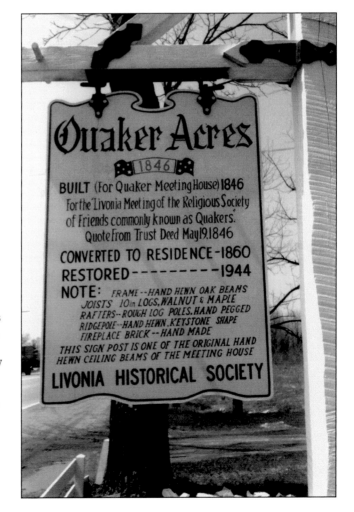

The Livonia Historical Society was organized in 1956. The group worked to establish a museum and to save and relocate old buildings important to Livonia's history. In the early 1960s, the city purchased the Gullen property on Seven Mile Road, called Quaker Acres, which became the Livonia Historical Society Museum. As the bicentennial approached, the Thomas Shaw House, the A. J. Geer Store, and the Detroit United Railway Waiting Room were all moved to the property.

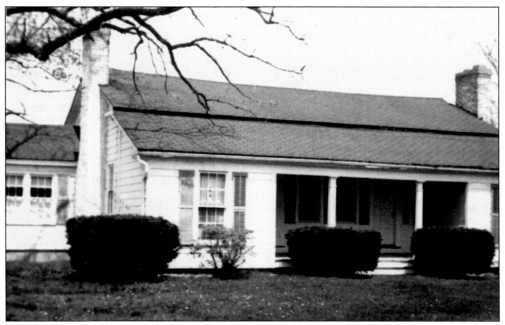

The Quaker Meeting House, seen in the early 1970s, had been converted to a residence and altered to suit the needs of the owners. Built in 1846, the meetinghouse served the Society of Friends (Quakers) from Livonia, Nankin, and Plymouth Townships. When the group disbanded in 1860, the property became the residence of the Roberts family, who had been members of the group. (Photograph by Edward Reid.)

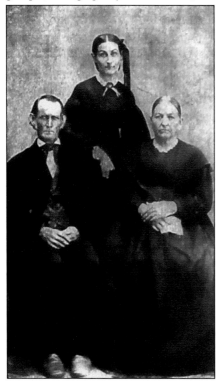

William Plumley and Sarah Harlan Roberts are pictured with their daughter Elizabeth around 1870. William and Sarah married in 1820 and had four children: Mary Ann, Phoebe, Elizabeth, and Ezekiel. The Roberts family migrated to Michigan from Bucks County, Pennsylvania, some time after 1841. The house remained in the Roberts family through son Ezekiel until about 1893.

Rudolph Kahrl was born in Germany in 1861. His parents, Harmon and Amelia, immigrated to the United States in 1880, when Rudolph was 19 years old. In 1886, his parents purchased 100 acres of land in Livonia along Seven Mile Road.

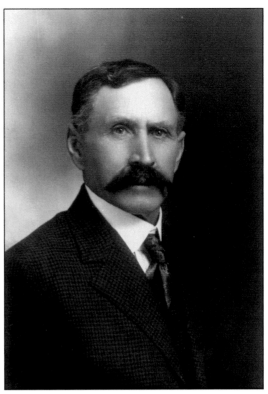

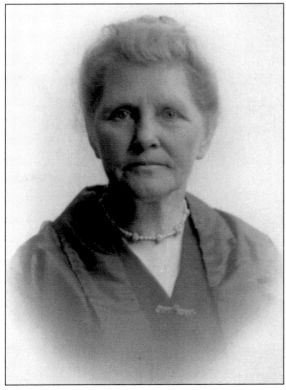

In 1890, Rudolph Kahrl married Emma Wollgast of Livonia, and the couple lived in the converted Quaker Meeting House. At some point, Rudolph's parents purchased land in Salem Township in Oakland County. In 1910, Rudolph and Emma were living on Base Line Road (now Eight Mile Road) with their eight children.

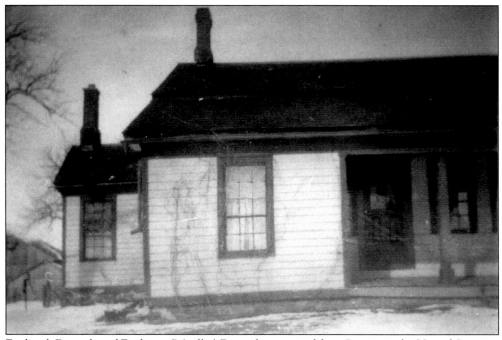

Frederick Dietrich and Frederica (Moeller) Dietrich emigrated from Prussia to the United States in 1882. They lived in the Detroit area for several years and then bought the Quaker Acres property around 1903. This photograph shows the house at the time the Dietrichs resided there.

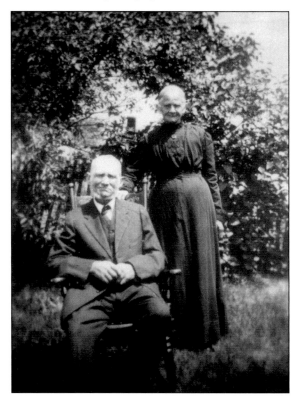

The Dietrichs pose in the yard of their home around 1910. The chair holding Frederick is now preserved at Greenmead. Frederick and Frederica had six daughters: Minnie, Elizabeth, Emma, Edith, Bertha, and Martha. Frederica died in 1923 and Frederick in 1929. Bertha continued to live in the house.

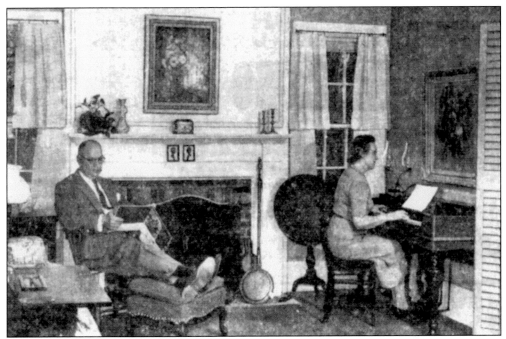

In 1944, Lloyd and Ann Gullen purchased the Dietrich property, which at that time consisted of 40 acres. Lloyd and Ann met at the Michigan State Normal College (now Eastern Michigan University), where Lloyd majored in education. After graduating, he worked at Livonia Center School and then taught high school in Romulus in the 1920s. Later he served as superintendent of schools in Clare and St. Louis, Michigan. (Photograph courtesy of the Detroit Times.)

The Gullens lowered the first-floor ceiling to create a second floor for Ann's art studio. Because Ann was of Quaker ancestry, the home held special meaning for her. The Gullens sold the building to the City of Livonia in 1961. In this photograph, two of the Gullen daughters—Bethel Adams (left) and Jean Anderson—visit their parents' former home in the 1970s.

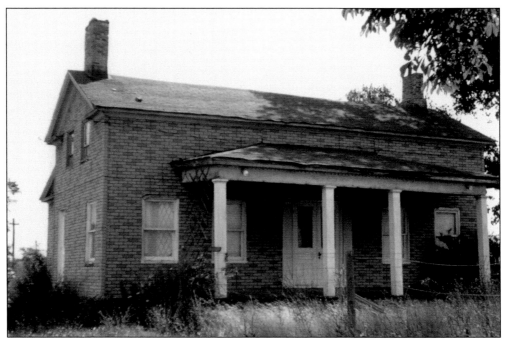

The Thomas Shaw House is shown at its original site on Six Mile Road. When Interstate 275 was constructed, the structure stood directly in the path of the highway. The Livonia Historical Society and the Livonia Historical Commission raised the funds needed to move the house to Quaker Acres in the fall of 1973.

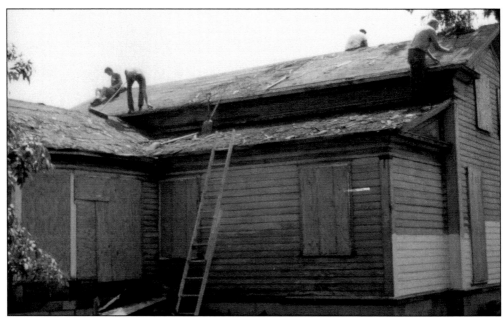

The Thomas Shaw House took on a new look as the process of restoration began. The original wood shingle roof was revealed, as were the original roof boards, some of which were 14 inches wide. The "brick coat" siding material was removed to reveal the original clapboard siding and Greek Revival details, such as the wide cornice line, corner returns, and pilasters (flat columns).

Robert Shaw, a descendant of the Thomas Shaw family, returned with his wife, Susan Kroner Shaw, to visit the house of his grandfather John. As a young boy, Robert spent several summers with his grandfather. He visited the house at Quaker Acres to recall those summer days of his boyhood. Robert also shared his memories of the home's interior with the historical commission.

William and Betty Shaw welcome members of the historical commission, arriving for a special dinner in the historic Shaw House as part of a family reunion weekend. William, another descendant of the Shaw family, returned to see the house. William said, "I wanted my children and grandchildren to see [the house] because I hope they will keep in touch in Livonia."

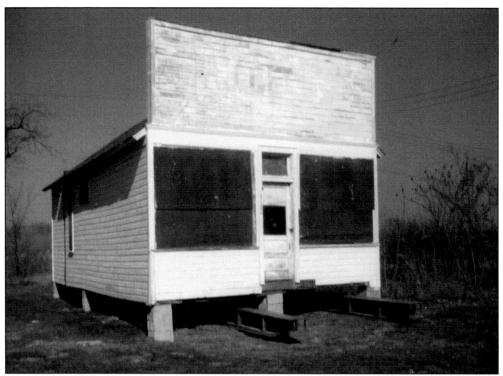

Following the Shaw House, the next buildings moved to Quaker Acres were the A. J. Geer Store (above) and the Detroit United Railway Waiting Room (below). The buildings were scheduled to be transported in November 1974, but the big snowstorm of Thanksgiving weekend delayed the move until January 1975.

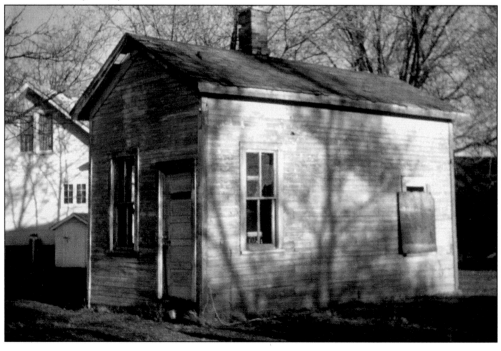

Chuck and Connie Wagenschultz (on the right) show interest in the items made by the tinsmith at the Heritage Fair. At Quaker Acres, Chuck was one of the primary volunteers who worked on the restoration of the Shaw House, while Connie established the organizational framework of the museum.

The first Heritage Fair was held in June 1974. Proceeds were used to restore the recently moved Shaw House. Here Mayor Edward McNamara draws the winning raffle ticket for one of the quilts made by members of the historical society.

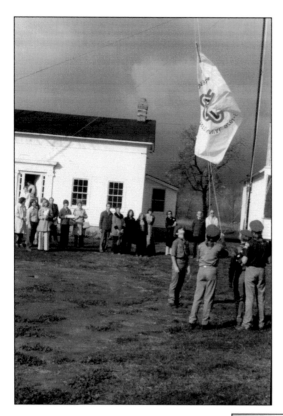

On October 19, 1975, Quaker Acres formally opened to the public. This marked the beginning of regular tours and exhibits at the Quaker Meeting House and Shaw House. In this photograph, Boy Scouts raise the official bicentennial flag.

Artifacts from the Ryder family were on exhibit in the Quaker Meeting House. The Ryders were among the early settlers in Livonia, purchasing a quarter section (160 acres) at Plymouth and Levan Roads. Small photographs of John and Alfred Ryder in their Civil War uniforms were displayed above their wood tombstones from Gettysburg. John served in the Michigan 24th (the Iron Brigade) and Alfred in the 1st Michigan Cavalry.

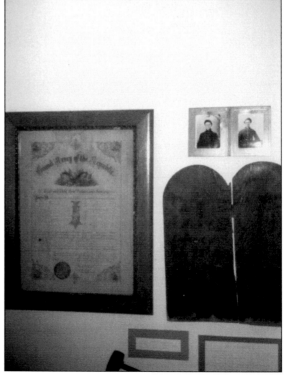

Two

MEADOW BROOK FARM/GREENMEAD

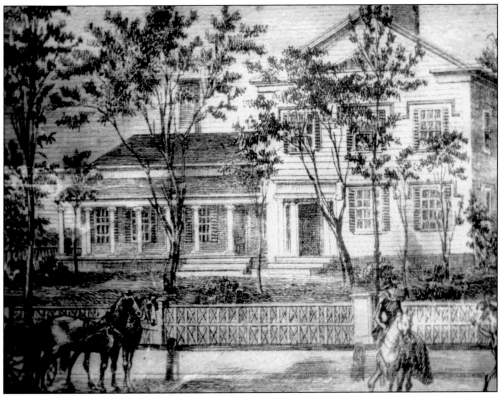

This image of the Simmons-Hill House was taken from an 1860 map of Wayne County. The City of Livonia purchased the 103-acre farm containing a Greek Revival house, barns, and farm outbuildings from the estate of Jean Boyd Hill in 1976. Mayor Edward McNamara stated at the time of purchase that the city's vision was to operate the property as a model farm, because agricultural land was rapidly disappearing in Livonia.

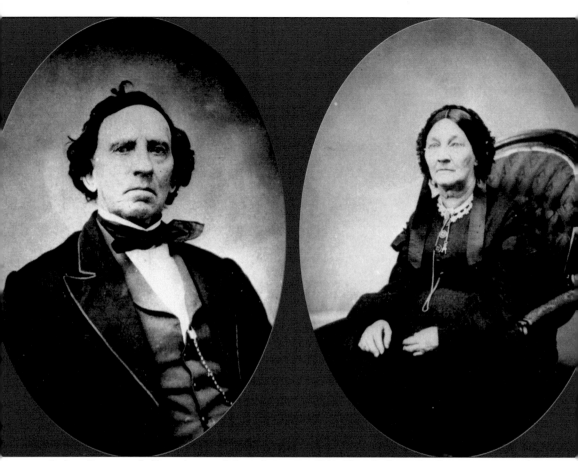

Joshua Simmons (left) was born in Massachusetts in 1801. Shortly thereafter, his parents moved to Bristol, Ontario County, New York. In 1824, when he had saved $225, he traveled to Michigan and purchased 160 acres in Livonia Township. He returned to New York and worked for an additional two years. Joshua married Hannah Macomber (right) of Bristol, New York, on January 13, 1826, and the couple moved to Michigan the following fall. After crossing Lake Erie on the steamship *Superior*, Joshua and Hannah Simmons hired teamsters to bring them out the Grand River Road to Base Line Road in Livonia Township. On the first night, Hannah stayed with the Thayer family about a mile north of the land Joshua had purchased. Joshua built a three-sided log structure with the help of two neighbors. Hannah joined him the next day to begin their life together on the frontier.

A drawing of the original Simmons log house was printed in Samuel W. Durant's 1877 *History of Oakland County*. Also pictured is a small frame house, which was most likely the second home of the Simmons family, although no documentation has been found to support this. All of the Simmons children lived in Oakland County after they were married, with the exception of one son.

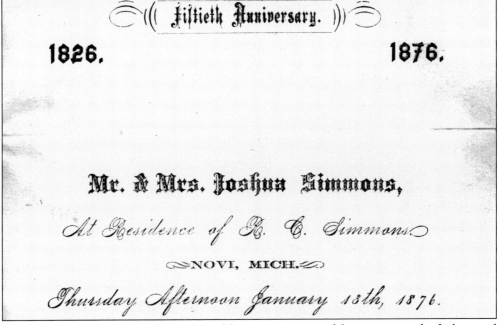

This invitation announces the 50th wedding anniversary celebration given for Joshua and Hannah at their son Richmond's home on Ten Mile Road in Novi Township. The couple's three sons presented them with an elegant carriage, according to a January 1876 *Detroit Tribune* article. Joshua died in 1882 at age 81, and Hannah died in 1894 at age 87. After Hannah's death, the property passed to her son Lawrence, then to his daughter Lucy Jane Simmons German in 1898. Following Lucy's ownership, her son Harry Simmons German held the property until 1915. Ella Goebel purchased the house, farm, and 113 acres in December 1915. Sometime between 1915 and 1920, the name of the farm was changed to Greenmead. Sherwin A. Hill and Jean Boyd Hill bought the property from Goebel in January 1920.

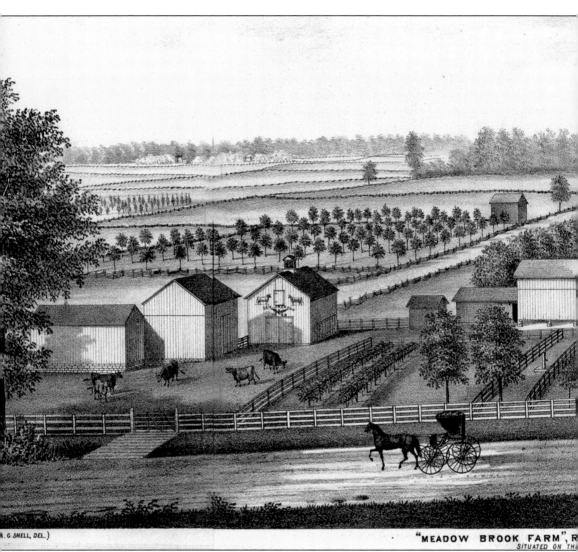

"MEADOW BROOK FARM", R
SITUATED ON THE

This drawing was printed in Samuel W. Durant's 1877 *History of Oakland County*. Because needs of the farm were the highest priority for any settler, the next building constructed after the log house was a barn, in 1829. Other outbuildings added later included a second barn, a carriage house, a small frame house, and five smaller outbuildings. Joshua and Hannah Simmons called their property Meadow Brook Farm. Their home, built in 1841 by Sergius P. Lyon of Farmington, was a fine example of Greek Revival architecture. The "upright and wing" configuration was very

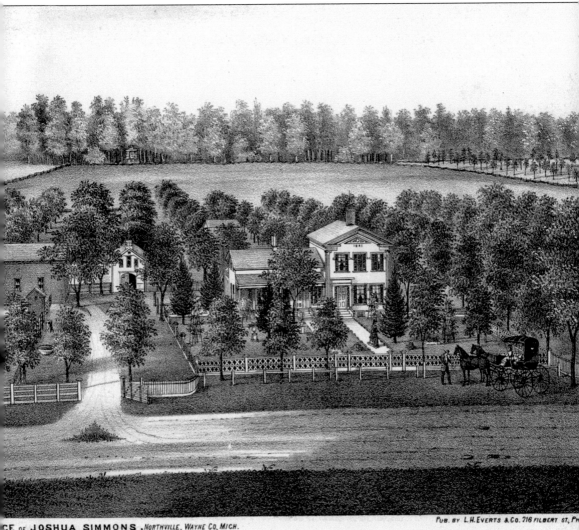

CE of **JOSHUA SIMMONS** , *NORTHVILLE, WAYNE CO, MICH.*
E OF FARMINGTON, OAKLAND CO, MICH.

Pub. by L.H.EVERTS & Co. 716 FILBERT ST, PH

popular and commonly used for houses built between 1830 and 1860. The Simmons home had many stylish embellishments, including Ionic columns on the porch of the wing, a beautiful front entrance with sidelights and simple entablature, corner pilasters, and drip mold window crowns. Joshua and Hannah had seven children: Richmond Clark (born in 1827), Lawrence Wellington (1829), William Tenny (1831), Joshua Morrell (1833), Mary Emiline (1835), Jennie Eliza (1839), and Helen Marnah (1845). Helen was the only child born in the stylish, new Greek Revival house.

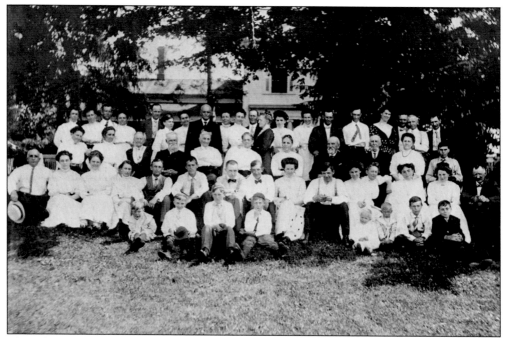

This photograph was taken at the 1909 Simmons reunion, attended by 55 family members and held at the farm. Admiration for the construction of the early barn was mentioned in a *Northville Record* article of July 2, 1909. The day was packed with outdoor activities for all. The *Record* reporter observed, "The automobile race between Belle Simmons and Mary Yerkes was a tame affair and only three farm pigs killed."

Many Simmons family members were present at the ribbon cutting for Joshua Simmons Drive in June 1991. This was one of several events marking the 150th anniversary of the Simmons-Hill House. Shown cutting the ribbon are city clerk Joan McCotter and genealogist Dr. Richmond Simmons. The Friends of Greenmead contributed to the commemoration by funding a large bronze state historical marker honoring the farm.

At the 1909 reunion, the family voted "to have a reunion take place each century." Therefore, in the year 2000, the descendants of the Joshua Simmons family gathered at the homestead. Family genealogist Dr. Richmond Simmons organized the reunion and printed "Simmons Family Reunion" T-shirts for the event. Some 191 direct descendants plus their spouses and other guests traveled from 16 states to attend. Richmond is pictured below in the second row, center, with his immediate family members.

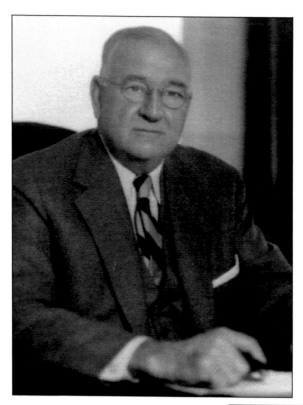

Sherwin Alonzo Hill was born on October 22, 1885. He graduated from the University of Michigan with a bachelor of laws degree in 1907 and was admitted to the bar that same year. Joining the Detroit law firm of Shaw, Warren, Cady, and Oakes, Hill practiced corporation law in the areas of admiralty matters, marine insurance, shipping, and banking. He sat on the board of directors of many businesses, banks, and clubs.

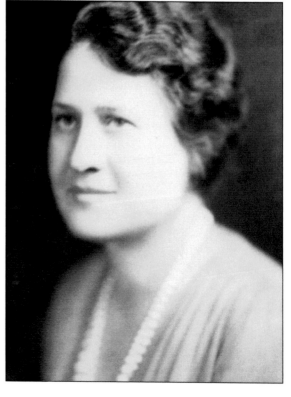

Born on November 19, 1889, into a wealthy Baltimore family, Jean Boyd Allen married Sherwin A. Hill on June 1, 1912, in Roland Park, Maryland. She was a longtime member of the Detroit City Club and served as treasurer of the Sarah Ann Cochran Chapter of the Daughters of the American Revolution for 35 years.

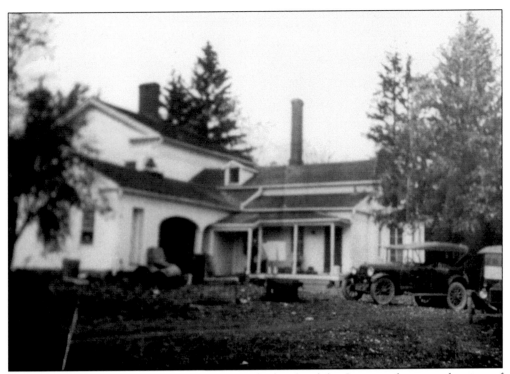

The photograph above depicts the rear, or south, facade of the Simmons house at the time of the Hills' purchase in 1920. The Hills noticed the Simmons house for sale on their way to and from the Meadowbrook Country Club, which was (and still is) located about one mile west on Base Line Road. The Hills sold their home on Boston Boulevard and lived at the Whittier Hotel in Detroit for a year while they remodeled and restored the home. The view below shows the rear of the house after the Hills had completed remodeling. Among the many changes were the following: the former vehicle storage area became a lovely sunroom, the kitchen was enlarged and updated, and the site of the front staircase was moved to expand the front parlor.

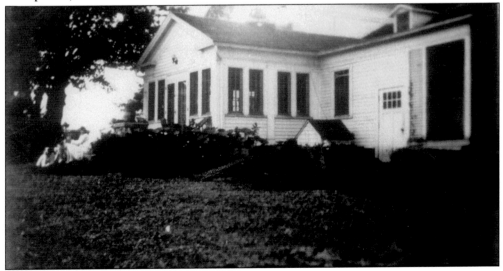

From left to right, Delphia Allen Hill, Ralph Clemens, Ray Clemens, Ward Clemens, and Jean Boyd Hill are pictured here around 1928. Ralph, Ray, and Ward were the children of the hired farmer, Russell Clemens, who worked for the Hills from 1926 to 1930. Sherwin A. Hill's avocation was breeding cattle, and he often exchanged animals with Charles A. Wilson of Meadow Brook Farm in Rochester, Michigan, to improve and maintain the highest quality of his registered herd.

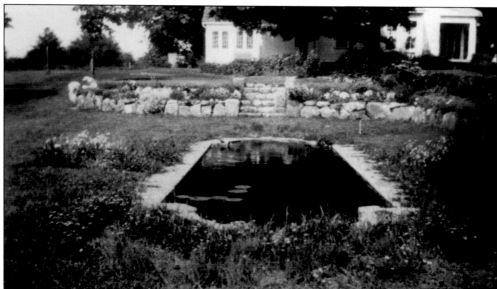

The goldfish pond and retaining wall for the sunken garden were constructed in the 1920s. Jean Boyd Hill, who was very fond of flowers, developed the gardens near the house, and the greenhouse was added to the carriage house in 1926. The pond and sunken garden are still extant today, maintained for 30 years through the devoted efforts of the Livonia Garden Club.

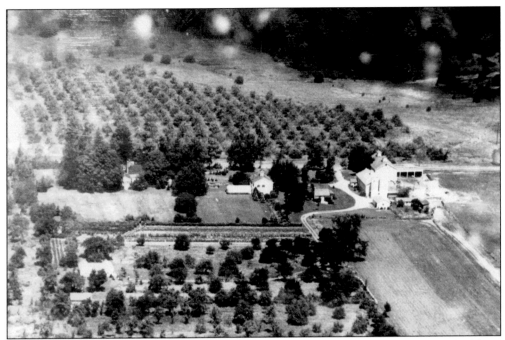

This aerial view shows the northwest corner of the Hill farm around 1950. The visible buildings are the greenhouse, the carriage house, the farmer's house, and the south and north barns. Greenmead was a working farm until the early 1960s, when Sherwin A. Hill died. The orchard north of Base Line Road (later known as Eight Mile Road) is now a subdivision.

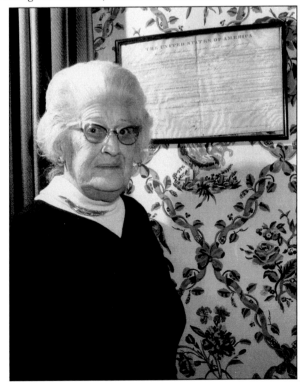

Jean Boyd Hill is pictured in 1971 with the original land patent from the United States to Joshua Simmons, signed by Pres. John Quincy Adams in 1825. Hill, recognizing the importance of Greenmead and its history, had it placed on the National Register of Historic Places that same year.

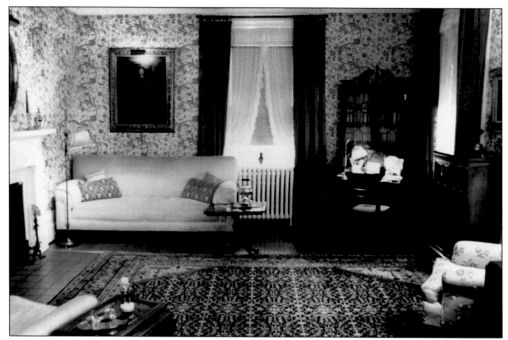

The west side of the parlor is seen around 1970. Jean Boyd Hill's taste in decorating reflects a desire for comfortable, traditional furniture that will stand the test of time. Some of the pieces were purchased at the time of her marriage, while others are antiques acquired later.

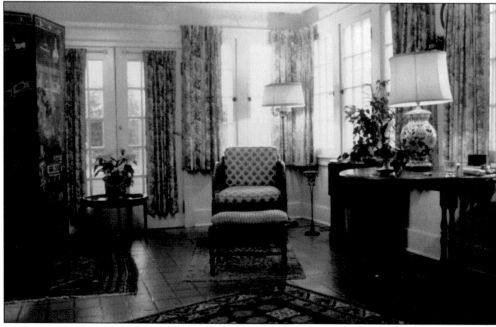

This photograph was taken around 1970, when Jean Boyd Hill lived in the house. The furniture in the light-filled sunroom includes, from left to right, an Oriental screen, a tray table with plant, a painted wood armchair with cane detailing and matching footstool, a radio/phonograph, a round drop-leaf table matching the chair, and Oriental area rugs on the tile floor.

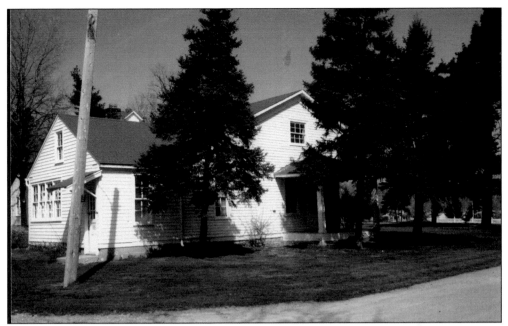

One of the reasons Greenmead is such an important historical site is that it has retained so many of its original farm outbuildings. While the farm was under the Hills' ownership, the hired farmer and his family occupied this house. The room on the left was added by the Hills. In 1997, the historical commission restored the building, which currently houses the permanent exhibit Livonia as a Township.

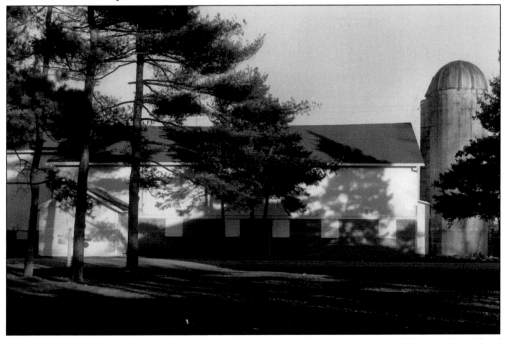

The south barn was constructed prior to 1877; Samuel W. Durant's 1877 *History of Oakland County* contains a drawing showing both the north and south barns. Sherwin A. Hill used this barn for his herd of 24 registered dairy cattle and added the two cement silos for grain storage.

The City of Livonia purchased Greenmead from Jean Boyd Hill's estate in 1976. The first priority was to open the Simmons-Hill House to the public as a museum. The Simmons-Hill House Museum dedication was held on September 18, 1977, with remarks by Mayor Edward McNamara and Shirley Bishop, historical commission chairperson. Seated behind Bishop are (from left to right) councilman Peter Ventura, Mayor McNamara, and councilmen Jerry Raymond, Robert Bennett, and Robert Bishop.

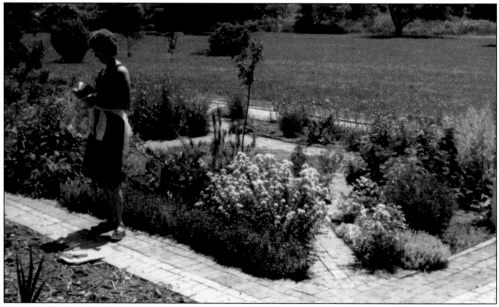

Mary Pulick, master gardener and historical commissioner, coordinated the activities of the volunteer gardeners around the Simmons-Hill House. Shown here is the herb garden, located on the south lawn in the former orchard. More than 30 other volunteer gardeners care for the remainder of the grounds around the house. Greenmead and the historical village would not function without their many dedicated volunteers—not only the gardeners but also the tour guides and special event workers.

This garden trellis was built on the south lawn with funds donated by the Stevenson High School student senate. Work began on the gardens shortly after the city acquired the property. Rudy Fedus, another master gardener, laid the brick paths in the herb garden and also worked on the selection of plant materials.

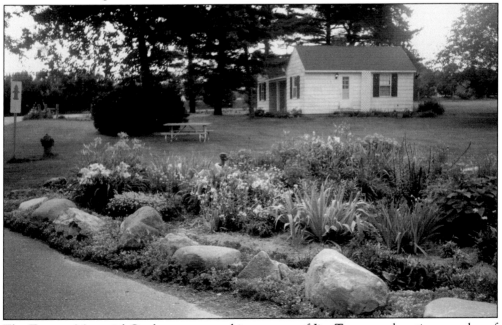

The Trenner Memorial Garden was created in memory of Jim Trenner, a longtime member of the city grounds maintenance staff. A small plaque bears the dedication. Virginia B. Matley and Joan Peterson maintained the garden for many years.

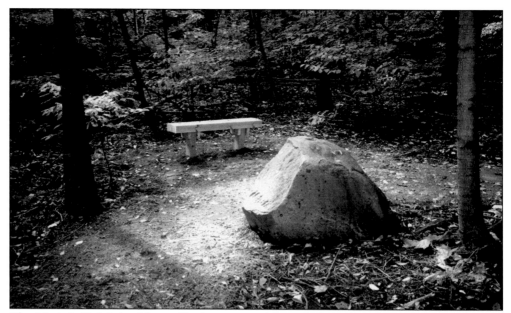

The Virginia B. Matley Nature Trail was named for a dedicated garden volunteer. The trail meanders along the old farm lane through the wooded area west of the meadow and south of the house. It was a combined project of the Livonia Garden Club and four Senior Scouts working to earn their Eagle Scout designation. It was carefully planned ahead and completed in five stages by Robert Cambridge, Patrick Oakley, and Matt and Jeff Guibord.

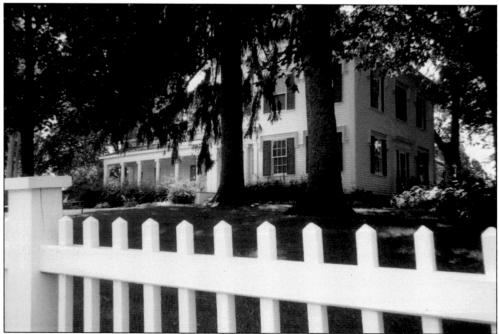

The Simmons-Hill House is shown as it looks today. Among future plans are the restoration of the interior, including updating the electrical and mechanical systems, and the restoration of the rooms to their appearance at the time the home was purchased from the Hill estate. Many activities are held year-round at the Simmons-Hill House and the Livonia Historical Village.

Three

THE 1850S BUILDINGS

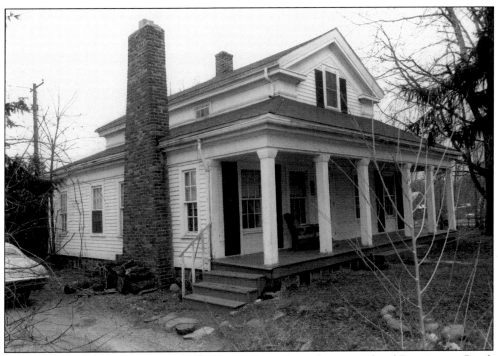

Built in 1843, the Nathan Kingsley House was located on the west side of Farmington Road, north of Five Mile Road. Nathan built the house in the basilica form of the Greek Revival style, a design that is unique to southeastern Michigan. He constructed it at the time of his marriage to Mary Grace Lambert. Nathan and Mary had four children: Robert, Horace, Clare, and Emma. Robert and Clare died in childhood.

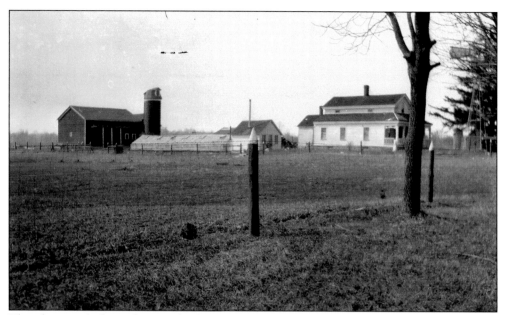

This photograph shows the Kingsley farm around 1915. Over time, Nathan B. Kingsley increased his acreage and production. In the 1880s, he employed a hired man from Scotland, Joseph McEachron, who eventually married Nathan's daughter Emma in 1890. Emma and Joseph lived with Nathan B. and Mary Kingsley and ran the family farm. Nathan died in 1898 and Mary in 1902; the farm then passed to Emma.

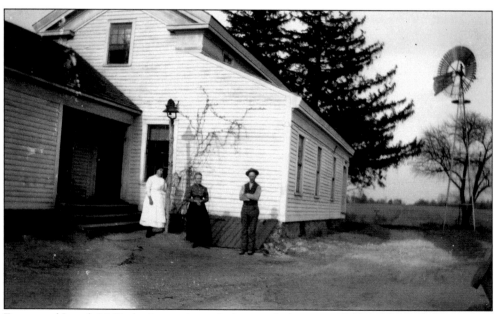

Emma and Joseph McEachron are pictured, along with their niece Lillian Maney (left), standing at the rear of the farmhouse around 1912. After Joseph died in 1914, Emma sold the property. In 1925, the farm was acquired by a group of people who developed Coventry Gardens subdivision, but the house was sold separately. Eventually the home was purchased by Edith Allan of Allan Realty, who donated the house to Livonia along with $1,000 toward the moving cost.

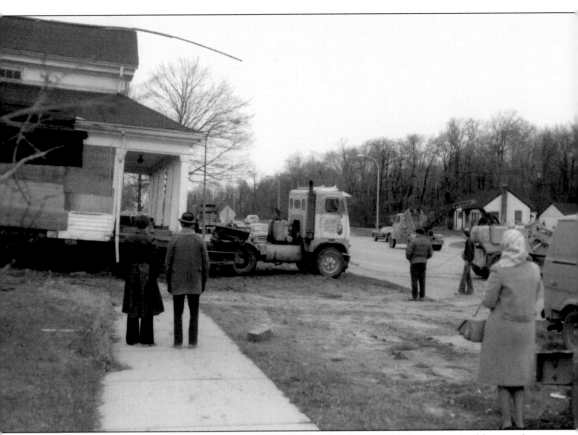

The Kingsley House was transported onto Farmington Road in 1977. To move a building such as this, support structures called cribs are constructed in the basement. The cribs are made up of alternating layers of wood beams stacked like Lincoln Logs. Their purpose is to support the weight of the house after it is jacked up off the foundation. After the structure is jacked up, metal beams called skids are placed under the house for support, and the house is lowered back down onto the skids. Wheels are then placed under the skids, and the house is ready. Moving day required careful coordination with the electric company, gas company, Wayne County Road Commission (traffic lights), telephone company, and Livonia Police Department to both ensure safety for the house and prevent service disruptions to local residents.

This photograph shows the kitchen on its original site after the last occupying family had moved. Very minimal changes were made over the years. The previous owners had used this room as a dining room and the small bedroom nearby as the kitchen.

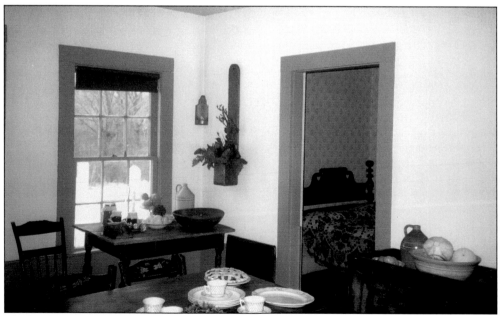

The kitchen was restored to its likely c. 1850 appearance. Much of the activity of the household would have taken place there. The large antique table in the center of the room would have been used as both a working and eating surface. To the right, the dry sink allowed for food preparation. Water was carried into the house from an outside well.

The parlor is pictured after restoration. The handsome window moldings and wide baseboards are appropriate for the most formal room in the house. The wallpaper is a reproduction of paper appropriate for the time period. The Sheraton fancy chairs, the two Windsor chairs, and the spool table beneath the mirror are antique but not original to the house and were purchased with a Quester grant.

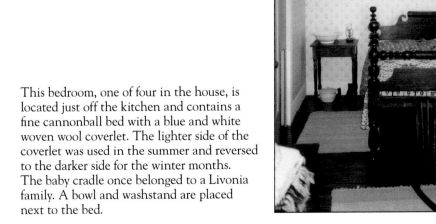

This bedroom, one of four in the house, is located just off the kitchen and contains a fine cannonball bed with a blue and white woven wool coverlet. The lighter side of the coverlet was used in the summer and reversed to the darker side for the winter months. The baby cradle once belonged to a Livonia family. A bowl and washstand are placed next to the bed.

The Nathan Kingsley House formally opened on September 7, 1986, with Mayor Edward McNamara speaking at the ceremony. Welcome remarks were given by Betty Jean Awrey, president of the Livonia Chamber of Commerce, which had donated over $20,000 toward restoration of the house. Also present were Barry Ryan and Laura Millard Ryan, the great-great-granddaughter of Nathan B. and Mary Kingsley.

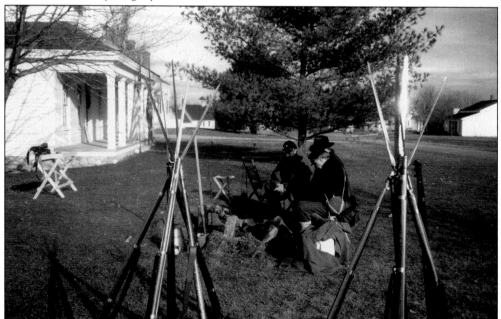

The Michigan 17th Regiment reenactors cook dinner over an open fire while the ladies decorate the Kingsley House for the holidays. Their Civil War uniforms and equipment are authentic reproductions.

From left to right, Sandi Pritchard and her grandson Alex, along with Kathy Sekerke and Jessica Williamson (Alex's mother), are fortified with refreshments following an afternoon of decorating for the holidays. The Michigan 17th reenactors entertained while visitors toured the buildings in the Livonia Historical Village.

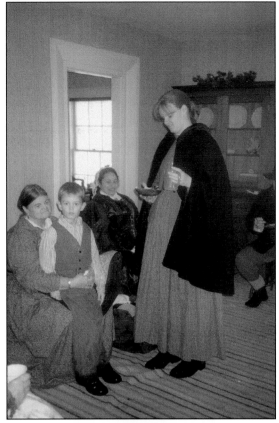

The Kingsley House is pictured 20 years after its move, having settled into its surroundings.

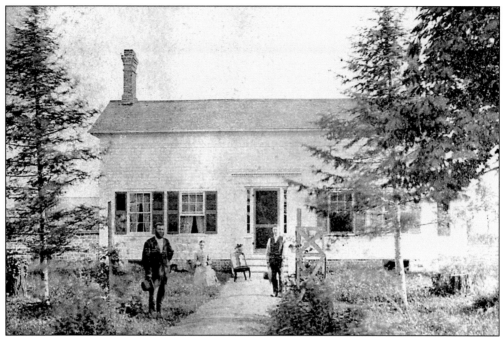

The Thomas Shaw House is shown about 1876. Thomas and Hannah Shaw emigrated from Wysall, Nottinghamshire, England, in 1836 with their three children: Ann, Eliza, and John. In 1843, Thomas built a fine Greek Revival home but did not live long to enjoy it; he died in the spring of 1844. Seen above are Thomas and Hannah's son, John, his wife, Myra, and his son William.

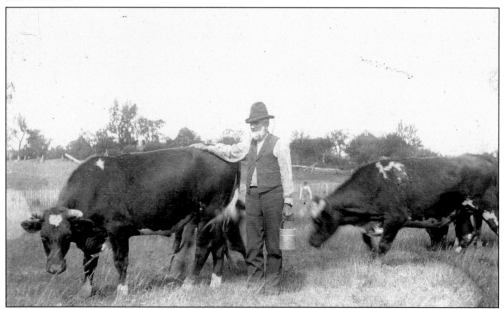

John Shaw poses for a photograph around 1900. After Thomas's death, John acquired the farm at the age of 20, assuming the responsibility for both the farm and the support of his mother and sisters. In 1850, he purchased an additional 40 acres of land adjacent to his property. He married Mary Ann Maiden of Redford Township that same year.

John Shaw wed Mary Ann Maiden in 1850.
Mary Ann died in 1875, and John married Myra
Hodge the following year. John and Myra did not
have any children. John became one of the most
prosperous farmers in Livonia Township. After he
retired, he lived in Plymouth for the remainder
of his life. Myra died in 1911 and John in 1916, at
the age of 92.

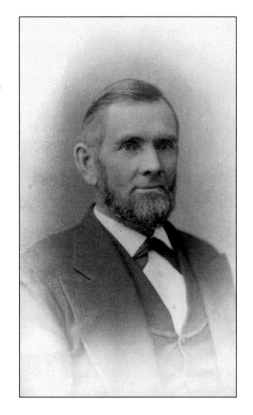

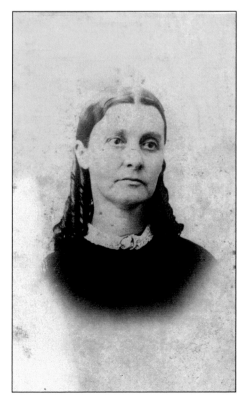

Mary Ann Maiden, born in 1830 in Redford
Township, was 20 years old when she and John
Shaw were married. Mary Ann and John had
three children: Emma, John Thomas, and
William Robert. In addition to the many usual
household tasks, Mary Ann also spent many
hours making quilts with her husband's mother
and sister.

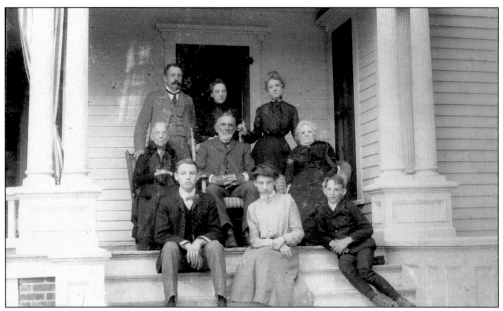

This photograph was taken around 1900 on the porch of William and Ella Shaw's home in Ovid. Pictured here, from left to right, are the following: (first row) John C. Shaw, Carolyn Shaw, and Robert Shaw; (second row) Myra Shaw, John Shaw, and Ella's mother, Laura E. Doane Partridge; (third row) William Shaw I, Ella Partridge Shaw, and Ella's sister Carrie Partridge.

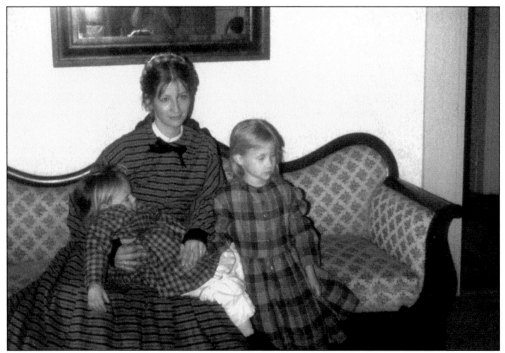

Beth Turza and her children, a sleepy Rebecca (left) and Jessica, relax on the empire rococo revival sofa after a ladies' tea. As family members of the Michigan 17th reenactor group, they are dressed in clothes authentic to the Civil War period.

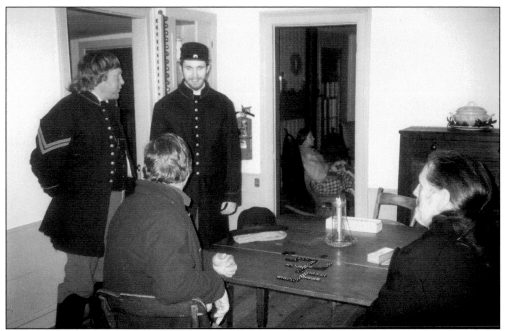

Joe Pensyl (standing, left) and an unidentified reenactor watch Bill Mountain (seated, left) and Bob Pollak (right) play dominos during a Christmas candlelight tour at Greenmead. Jackie Schubert relaxes in the sitting room beyond. The Michigan 17th Regiment reenactors volunteer as docents in the Kingsley and Shaw Houses, wearing authentic Civil War uniforms.

The Shaw House is decorated for Christmas, just as it would have been in the 1850s. All the buildings at Greenmead are decorated appropriate to their time period. In the mid-19th century, Christmas trees were a new idea in America, and if a family had one, it would have been a tabletop tree. At the time, holiday decorations would have been simple, natural, and homemade.

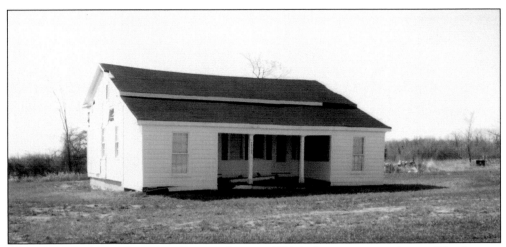

The meetinghouse at Greenmead is seen here in 1981, before restoration began. The Livonia Meeting of the Society of Friends (Quakers) was organized in 1833 as part of the liberal, or Hicksite, branch. The group originally met in a log structure, then built a larger meetinghouse in 1846. The new building was constructed in the traditional meetinghouse style, with separate entrances for men and women. After being moved to Greenmead, the name of the building was changed to the Friends Meeting House.

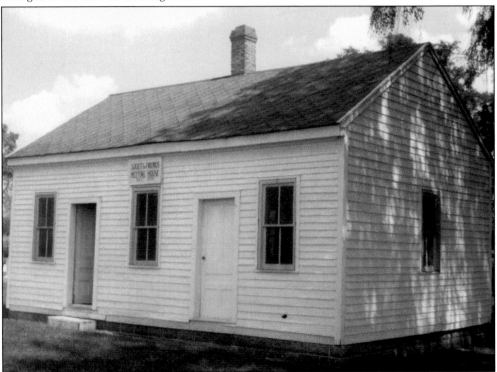

This photograph shows the Ohio Friends Meeting House, which was the model for the restoration of the meetinghouse at Greenmead. After much research and discussion, the historical commission decided to restore the building to its 1840s appearance. Quaker architecture was researched in Pennsylvania, Indiana, and Ohio. The restoration committee traveled to Ohio and took measurements and photographs of the structure for future reference.

The benches in the Friends Meeting House at Greenmead were modeled on those in the Ohio building. The typical meetinghouse was divided into two sections, with entry doors to each area. Participants sat on plain wood benches—men on one side and women on the other—and a movable partition usually separated the areas. The elders sat on a raised platform opposite the entry doors.

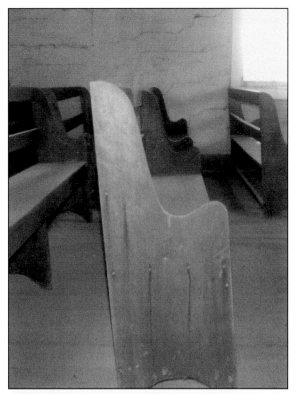

Because the building had been used as a residence for many years, its interior walls were removed to restore the structure to its initial configuration. Every effort was made to retain the original materials. The interiors of Friends meetinghouses were very plain and utilitarian. The walls were typically white, with the woodwork painted gray. Local Friends donated $1,000 toward the restoration.

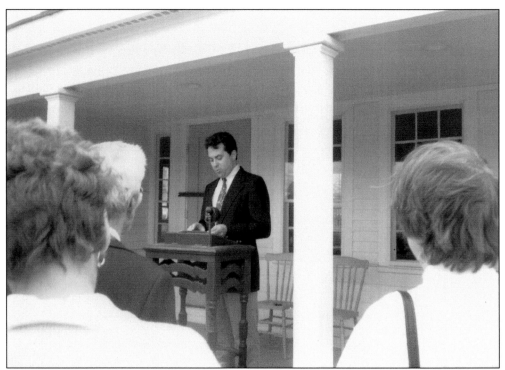

Michael McGee, vice president of the Livonia City Council, speaks at the opening of the Friends Meeting House in May 1994. The lectern was donated by a Detroit Friends group, and the chairs behind McGee are from a Canadian Friends meetinghouse.

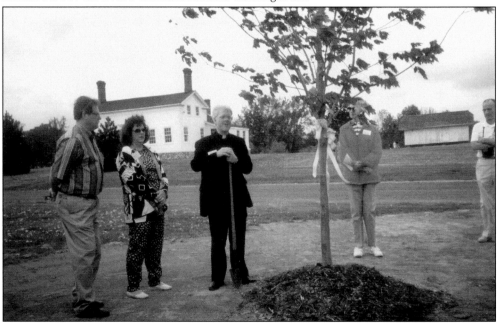

Descendants of the Dietrich family planted one of several walnut trees that they donated to the Friends Meeting House in memory of family members. Descendants of the Roberts and Kahrl families were also in attendance on opening day.

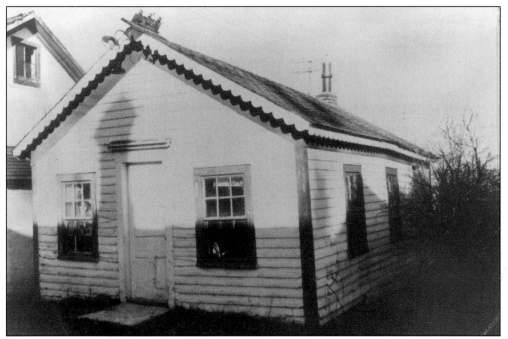

Judge Alexander Blue's office was once located behind his house on Middlebelt Road. Judge Blue was a prosperous Livonia farmer who served as justice of the peace from 1846 to 1874. He also served as township assessor, as Wayne County assessor, and on the Wayne County Board of Auditors. The structure to the left is a smokehouse, and beyond that is a barn. (Photograph by Edward Reid.)

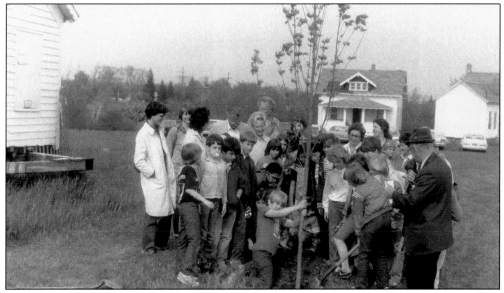

A group of ACAT (Alternative Classrooms for the Academically Talented) students from Cass Elementary School in Livonia planted a tree near the Judge Blue Office in the spring of 1983. The students then enjoyed an overnight campout at Greenmead involving history-themed activities such as the Greenmead History Hunt, which had been developed just for them. The students from Cass also planted flowers at Greenmead for many years.

49

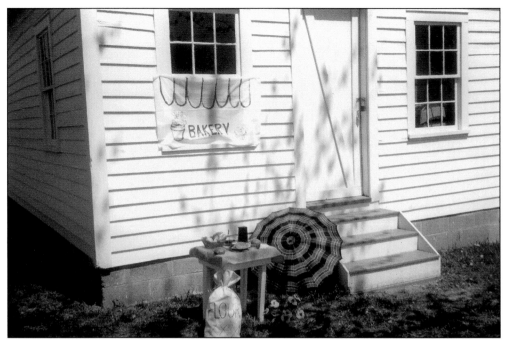

Here the Judge Blue Office is decorated for Peter Rabbit Day, an activity geared to young children. First the children were read *The Tale of Peter Rabbit*, and then they went from building to building looking for Peter and watching out for Farmer McGregor. The children stopped at the Judge Blue Office, which was the bakery, to see if Peter had been there. They ended their search at the Friends Meeting House, where they were rewarded with lunch.

With exterior restoration complete, the Judge Blue Office is pictured as it looks today. The wood shingle roof was restored in 1986, and some of the exterior clapboards were replaced. The scalloped trim is a puzzle; it is not the typical eaves trim of the era but will not be removed until more information is found. The structure retains the original plaster and wainscoting on the interior walls.

Four

THE NEWBURG
INTERSECTION

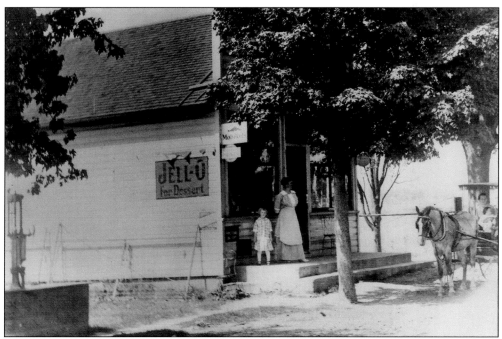

In 1910, the area in Livonia Township around Newburg Road and Ann Arbor Trail was known as Newburg. It consisted of a church, two general stores, a blacksmith, a cluster of homes, and the Detroit United Railway Waiting Room. A. J. Geer established his general store on Ann Arbor Trail west of Newburg Road in 1912. In the late 1950s, the spelling of Newburg was changed to Newburgh. In this book, Newburg is used in references to the name before this change and Newburgh issued in later references. The Newburg Intersection was re-created at the Livonia Historical Village with the buildings that remained there in 1970s. They were moved to Greenmead and placed in their original orientations to the compass and to one another; the goal was to depict the hamlet of Newburg around 1910–1925.

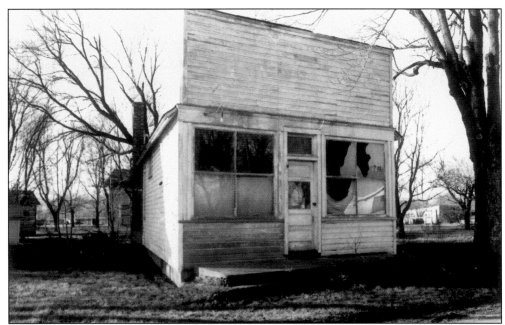

Operating until the 1950s under various owners, the A. J. Geer Store was a place to meet, chat with neighbors, and hear the latest news. The store, boarded up and unoccupied for over 20 years, was on the Livonia Historical Society's list of buildings to be saved in order to depict Livonia's rural past. The group purchased the store in 1974 and moved it to Quaker Acres. (Photograph by Edward Reid.)

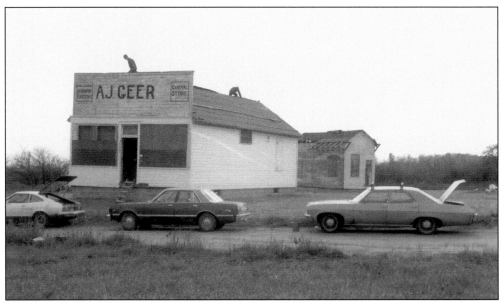

The A. J. Geer Store was first moved to Quaker Acres, then to Greenmead in 1976. Here the store sits on its new foundation, with the Detroit United Railway Waiting Room behind it. Volunteers prepare the roof for wood shingles. The image of the original sign, visible beneath a coat of paint, was traced, retaining its off-center placement. The restoration of the A. J. Geer Store was based on a 1915 photograph.

A. J. Geer's son Irving presented the 1913 A. J. Geer Store customer account book to the historical commission. The book contained the items purchased on various people's accounts and their prices. Some of the articles charged were canned goods, brooms, buttons, cigars, fabric, flour, kettles, lanterns, matches, knives, nails, coffee, paint, sugar, soap, sweaters, shirts, shovels, tobacco, tea (20¢), washtubs (75¢), and washboards (40¢).

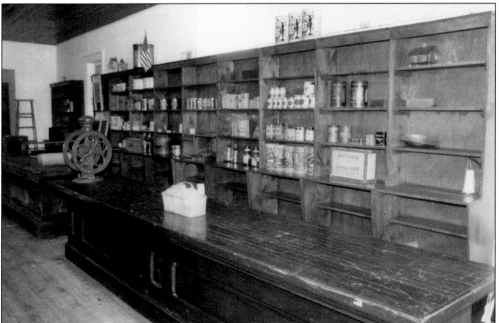

The items displayed on the shelves are the same as those listed in A. J. Geer's account book. Livonia Career Center students constructed the shelves along the wall, duplicating shelves found in the general store at Greenfield Village. Gladys Ryder, a longtime member of the historical society and the historical commission, donated the coffee grinder. Irving Geer donated an original Ferry Seed box.

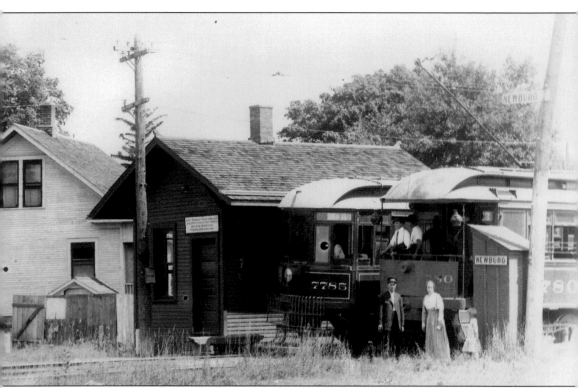

The interurban railway began operation around 1895, connecting small villages and towns. The interurban was immediately successful, and by 1899, a line was established between Wayne and Northville with stops at Newburg and Plymouth. The original name was the Plymouth Northville Railway, until it was consolidated into the Detroit United Railway. A fatal accident in 1912, in which a car derailed on the curve at Ann Arbor Trail and Newburg Road, resulted in the relocation of the track behind the A. J. Geer Store. Business boomed for the railway until the 1920s, when the proliferation of the automobile contributed to its demise.

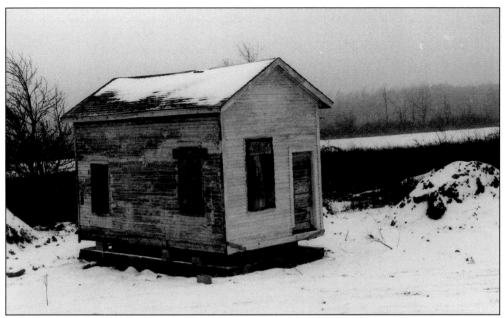

The Detroit United Railway Waiting Room was purchased by the Livonia Historical Society in 1974, moved to Quaker Acres in 1975, and then moved again to Greenmead in December 1976. The original waiting room was divided into two rooms—a small waiting area with benches for passengers and a larger freight space located three steps higher.

The waiting room went through many changes to be used as a residence during World War II. Extensive restoration, funded by the Livonia Historical Society, was required to return it to its original appearance. The dark areas on the paneling show the original location of the steps from the waiting room to the freight area.

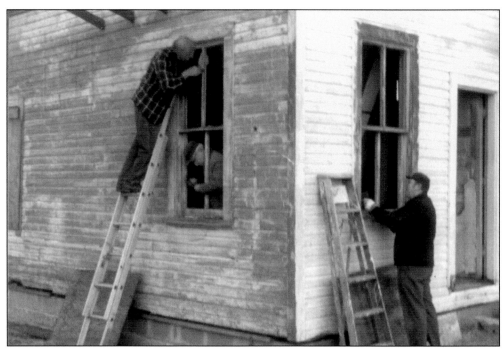

Historical society members scrape the windows of the waiting room prior to glass replacement. The exterior was spot primed and a second full prime coat applied. The exterior colors were replicated based on paint testing.

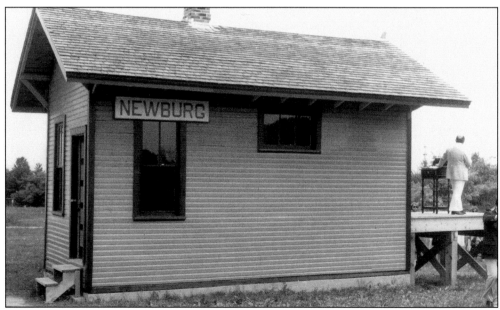

The opening ceremony for the renovated Detroit United Railway Waiting Room was held in May 1982. Jim Melosh, president of the historical society, welcomed visitors to the opening day of the first building restored in the Livonia Historical Village at Greenmead. Elements of the original structure that were re-created or restored were the wide freight door, freight platform, overhanging roof, and station sign over the side window.

In this photograph, the Bungalow stands on its original site at Ann Arbor Trail and Newburg Road. Built in 1913, the house was donated to Greenmead in 1979 and was moved to its new location the same year. The first floor contains a living/dining area in the front and a large kitchen in the rear. The second floor includes two bedrooms. The Geer family lived in the Bungalow while owning the adjacent store.

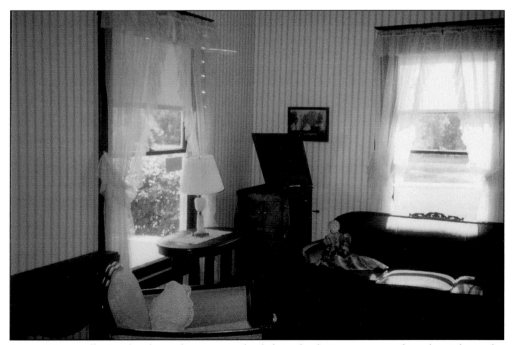

As a visitor walks in the door, the area to the left is the living room, and to the right is the dining room. Floor plans of bungalows were often more open and simple than in the earlier Victorian era. The furnishings date to the 1915 time period. The crank phonograph in the corner was purchased from the J. L. Hudson Company in 1915.

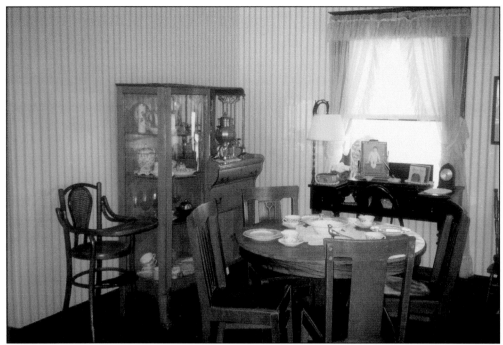

The bentwood high chair sits to the left of the oak glass-front china cabinet. The round oak table in the center of the dining area was a typical furnishing for this time period.

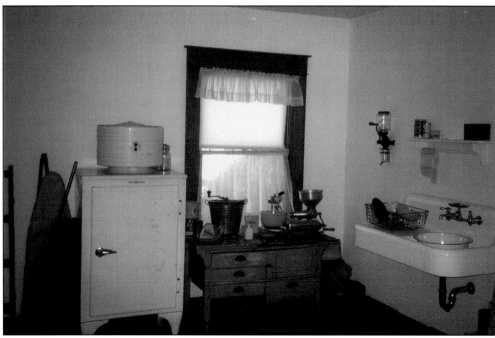

The Bungalow's large kitchen has a very early General Electric Monitor Top refrigerator, which was quite popular. A forerunner of modern built-in cabinets, the baking cabinet between the refrigerator and the sink was a wedding present to one of the Dietrich daughters. Most kitchens of the time incorporated a white or off-white color scheme.

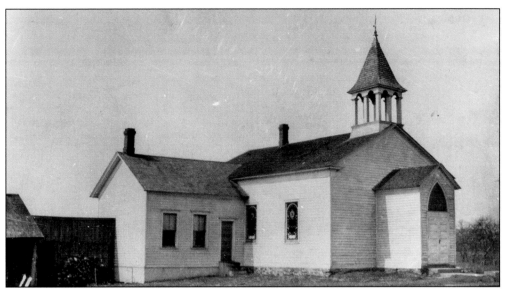

The Newburg Church appears on its original site, located across from the Newburg Cemetery, about 1900. Constructed in 1848, the church was authorized by the Michigan state legislature as a Presbyterian meetinghouse. In the early 1880s, the building was used as a Congregational church.

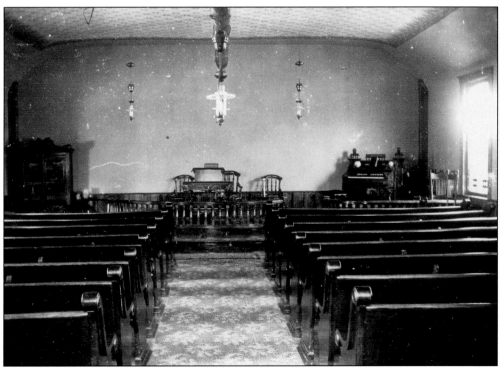

In 1888, the structure, seen here about 1910, became a Methodist church. The ceiling was covered with patterned wallpaper and the walls with textured wallpaper. The communion railing was added by the Methodist congregation. Its oak pews date from 1902. Kerosene lights hung from the ceiling. A tabletop lectern was used rather than a pulpit, and a pump organ occupied the right corner of the chancel area.

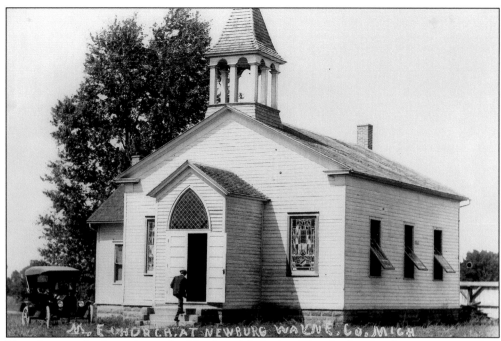

The photograph above shows the Newburg Methodist Church shortly after it was moved to the northeast corner of Ann Arbor Trail and Newburg Road in 1915. The building was placed on skids and pulled to its new location by horses. Stained-glass windows were installed on the east and west facades in 1902 and on both sides of the entrance in 1915. The photograph below depicts the Newburg Church 61 years later, in 1976. The Methodist congregation used the building until the 1960s, when it moved to a new space. The building stood vacant for a short time and then accommodated the Lord's House congregation. The group donated the church and the parsonage to the historical commission and subsequently built a new church on the site.

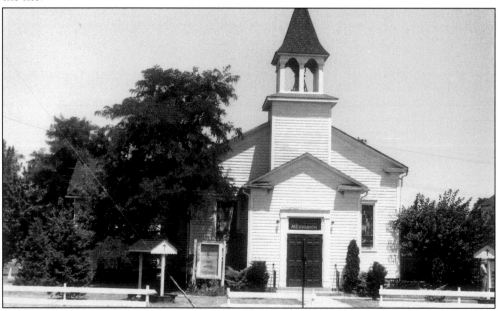

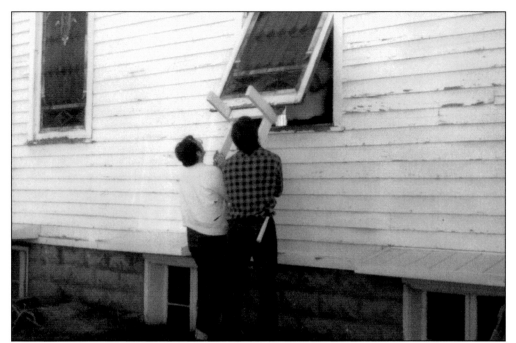

In preparation for moving the church to Greenmead, Ron Stanow (left) and Harvey Allen removed the stained-glass windows and stored them at Quaker Acres. Special wood crates were constructed to hold the windows until they were restored. The Friends of Greenmead financed their restoration, one of several Newburg Church projects funded by the group. The empty window frames were then boarded up.

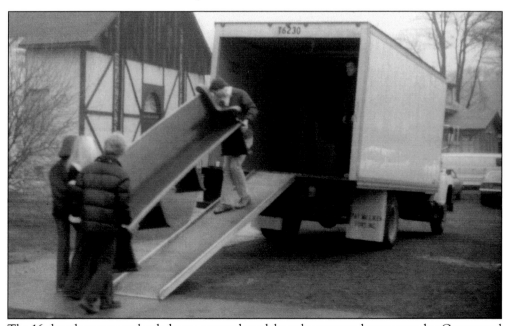

The 16 church pews were loaded onto a rented truck by volunteers and transported to Greenmead for storage. The bell was removed from the belfry and carefully lowered to the ground. Professional movers separated the Sunday school wing from the church building prior to the move.

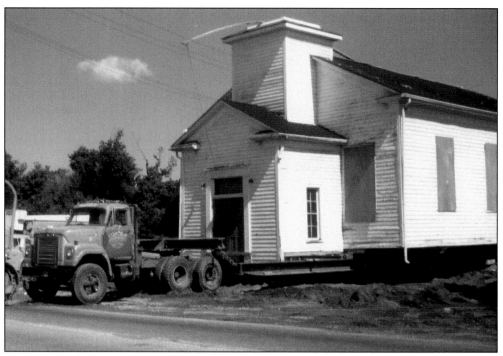

The church is ready to be pulled into the street for its journey north to Greenmead. This process proved difficult because after the truck turned onto Ann Arbor Trail, it had to immediately turn right onto Newburgh Road.

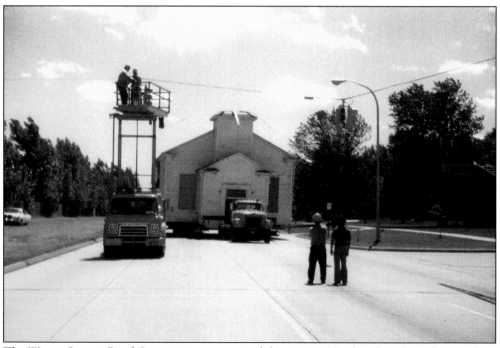

The Wayne County Road Commission crew raised the wires at Newburgh and Lyndon Roads in order for the church to pass underneath.

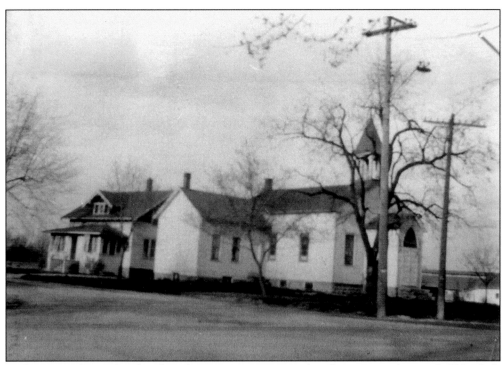

In the image above, the church and parsonage are pictured as they appeared around 1930–1940. In the photograph below, taken in 1984, the church has been placed in the same orientation at Greenmead as at its original site.

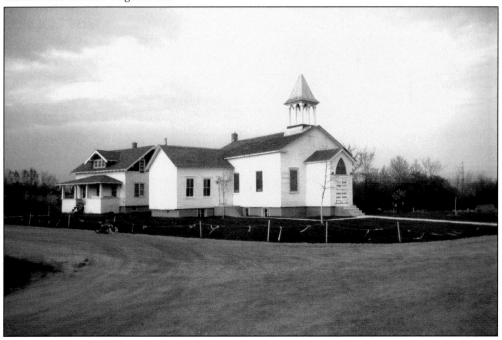

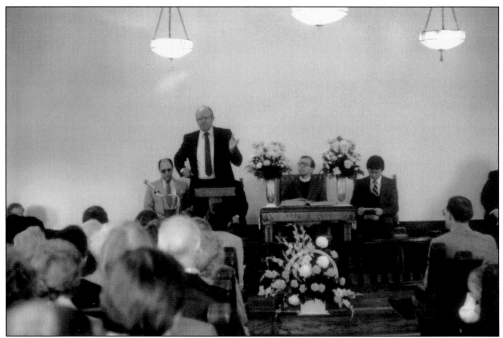

Mayor Edward McNamara gives the welcoming remarks for the opening ceremony of the restored Newburg Church on May 20, 1984. The Methodist choir sang at the festivities. Former congregation members, volunteers, city officials, and representatives of groups who raised money for the restoration were in attendance. The Friends of Greenmead donated over $49,000 for the project.

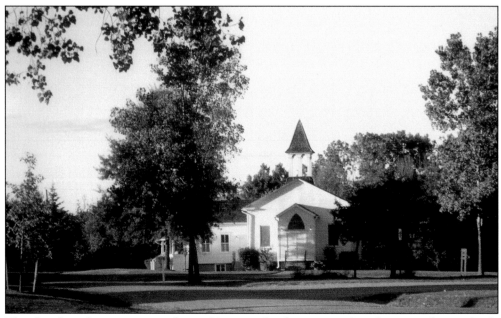

The church and parsonage are shown 20 years after being moved to Greenmead, completely settled into their surroundings. The Newburg Church is available for wedding ceremonies.

The parsonage is pictured above around 1930. The church acquired a new full-time minister and needed to provide him with a residence. The Ladies Aide Society raised most of the $4,300 needed for the construction. The first floor has four rooms and the only closet in the house. The second floor includes three bedrooms and a bathroom. The porch was enclosed shortly after the house was built. The restored parsonage is seen below at Greenmead. It was occupied until 1977, when the Lord's House congregation decided to build a new larger church and offered to donate the house to Greenmead. It was moved in July 1977, on the same day as Newburg Church. Used as the caretaker's home, the parsonage was restored by Harvey Allen, an early caretaker and volunteer at Greenmead.

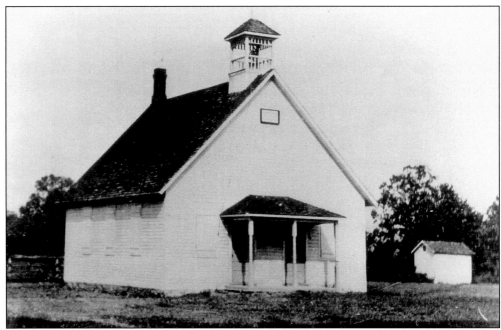

Newburg School, constructed in 1861 on Newburg Road north of Ann Arbor Trail, replaced a log school on the same site. It was a typical one-room school with two entry doors and two cloakrooms. The winter term was held from November through March and the summer term from May through September. This allowed the children to work on the family farm during the planting and harvesting seasons. Around 1880, the school term was changed to a nine-month schedule, from September through May.

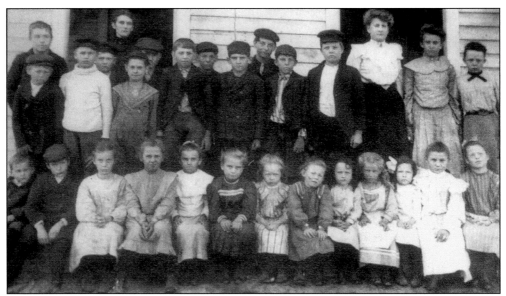

Zaida McClumpha's 1902–1903 class poses in front of Newburg School. In 1898, the red Newburg School was painted white. The frame building continued to be used until 1922, when it was replaced with a two-story, four-room brick structure. The old school building was moved to a nearby site.

Miss Ferrand taught at Newburg School from 1914 to 1918. Teachers were usually replaced every year in order to avoid paying increased salaries. The fact that the school board retained Miss Ferrand for four years suggests that she must have been an outstanding teacher. She later taught for many years in the Plymouth school system, where she was honored with a school named after her. In 1917, while Miss Ferrand was teaching at Newburg School, the building gained electricity.

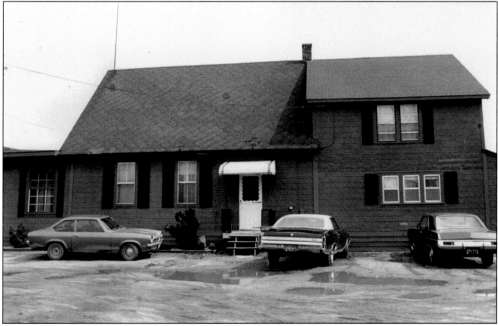

Newburg School was being used as an apartment building in 1975. Moved to Ann Arbor Road between Newburgh Road and Ann Arbor Trail, the building had been divided into three apartments after multiple additions. It was placed on a list of historic buildings in 1976, when the city passed the first Historic Preservation Ordinance.

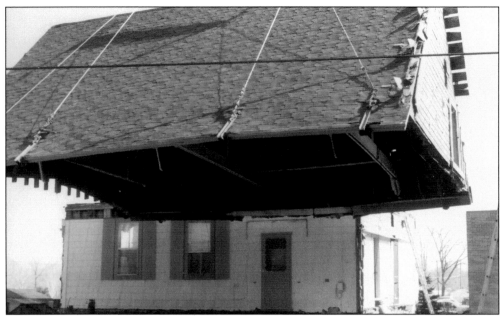

In 1987, the Newburg School building was prepared for its move to Greenmead. It was necessary to remove the roof in order to pass beneath utility wires. Additions were also removed, and only the original part of the building was transported. Even without the roof, the structure was still too tall to fit under the railroad viaduct over Newburgh Road. The moving route was therefore detoured from Newburgh east to Levan Road and then back to Newburgh. Friends of Greenmead helped to fund the relocation.

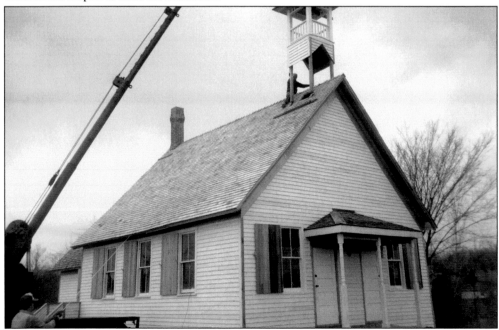

The original belfry was removed sometime after the school closed. Here a reconstructed belfry is lowered into place with a crane. Old photographs were used to help replicate its original appearance.

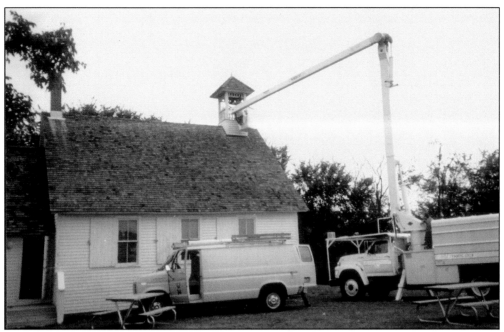

A new bell was purchased with funds donated by the Sand Hill Questers. It was purchased from an antiques dealer in Tecumseh who had been a Livonia fireman. The school bell was carefully installed in the belfry using a cherry picker, which hoisted both it and the crewman.

September 20, 1990, was Newburg School's opening day in the historical village. The restoration was partly financed by a $50,000 Michigan equity grant. The Livonia Michigan Sesquicentennial Committee also raised over $20,000 toward the moving and restoration of Newburg School. Livonia city officials, Greenmead volunteers, and Livonia school administration and teachers attended the opening ceremony.

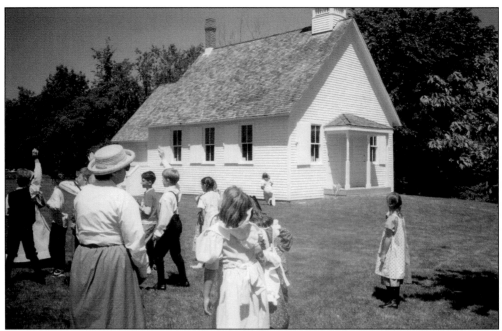

Students from the Livonia Public Schools experience a Day in the One-Room School at Greenmead. Specific curricula and activities were developed to enhance this ongoing living history day for the children. The preparation of this unique school program, patterned on subjects taught in the 1910–1920 era, was funded by a Livonia Public Schools mini-grant.

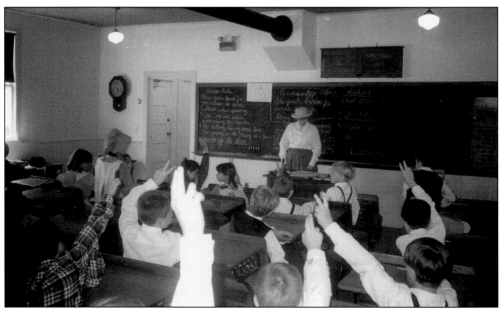

Class is in session at Newburg School. For the experience, children and teachers are encouraged to wear period clothing. The textbooks used by the children are *McGuffy's Eclectic Reader*, *Ray's Arithmetic*, and *Webster's Elementary Spelling Book*. The wood box above the blackboard contains five vintage maps used in geography courses. The blackboard was originally in the Stark School. The Rotary and Kiwanis Clubs donated funds for 15 desks.

Five

THE CRANSON-HINBERN AND ALEXANDER BLUE HOUSES

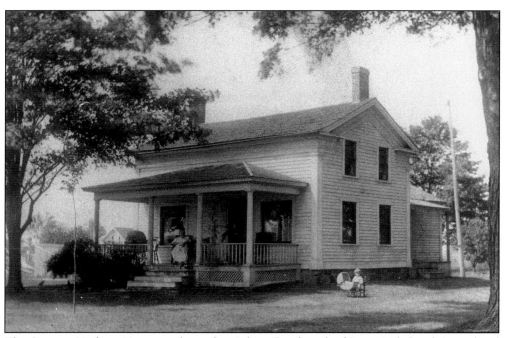

The Cranson-Hinbern House was located on Inkster Road south of Seven Mile Road. Samuel and Percis Cranson came to Livonia in 1832 and purchased one and three-tenths acres of land. The original house, constructed in the 1830s, consisted of only two rooms. The front section was added around 1850 and subsequently updated with Queen Anne ornamentation and windows around 1900. The Cransons had six children and farmed land across the road in Redford Township.

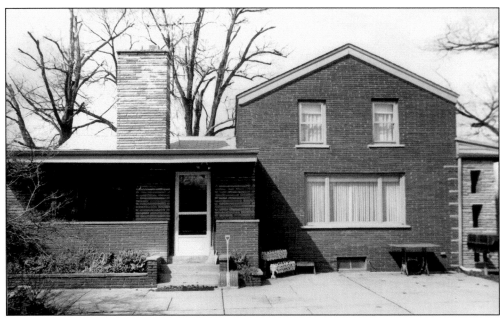

The house was updated in the 1950s. A family room was added, the exterior finish changed to brick, and modern windows were installed. Reke Hinbern purchased the property for $800 in 1902. It remained in the Hinbern family until 1984, when the house was sold to the Southland Corporation, which donated it to Greenmead. There it was used as an interpretive center, office, and gift shop.

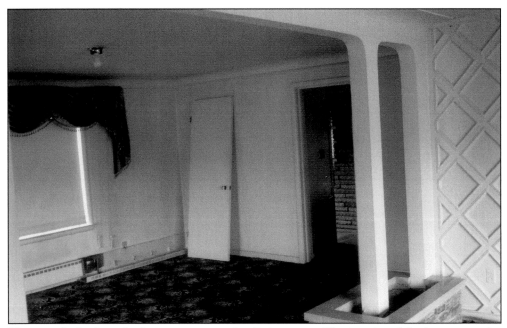

This view looks from the living room into the dining room. The interior of the house was also updated in the 1950s. Originally two separate rooms, the space was altered by removing most of one wall, leaving support beams to create a room divider effect, a feature that was very popular in the 1950s and 1960s.

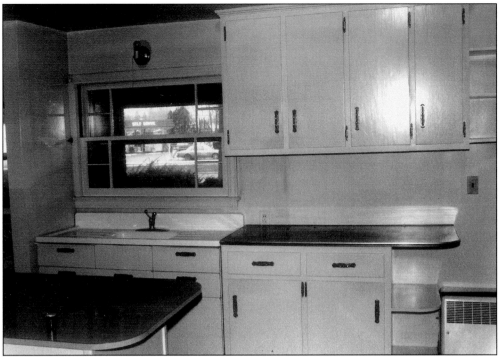

The Hinbern family modernized the kitchen in the 1950s with changes typical of that era. The counter projecting from the wall was a forerunner of the modern kitchen island. The counter surface was linoleum, a common surface material used at the time.

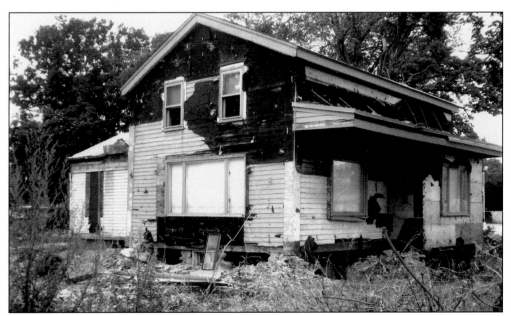

The historical commission decided to restore the house to its c. 1900 appearance based on a photograph from that time period. Before the house was moved, the exterior brick was removed, revealing the Greek Revival detailing and the clapboard siding. The 1950s-era family room was also removed to correspond to the restoration.

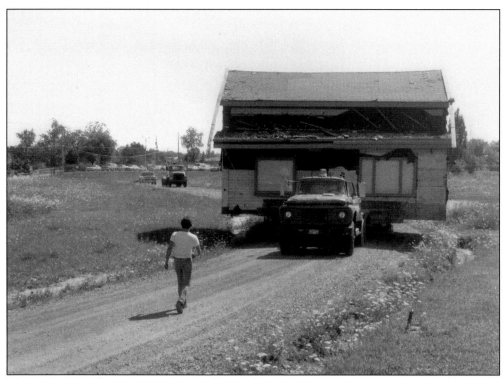

The Cranson-Hinbern House is driven along Joshua Simmons Drive on the Greenmead grounds as it slowly makes its way to its new location next to the historical village.

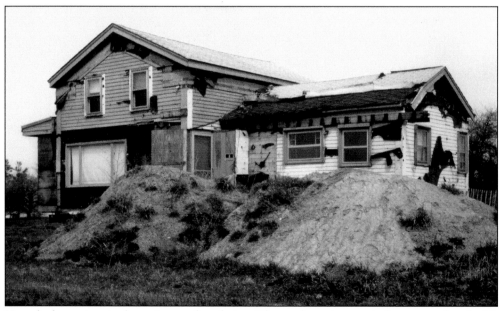

Here the house is poised over its new foundation. The modern picture window was replaced with windows typical of the early 20th century. The Greek Revival wide cornice line is clearly visible in this photograph.

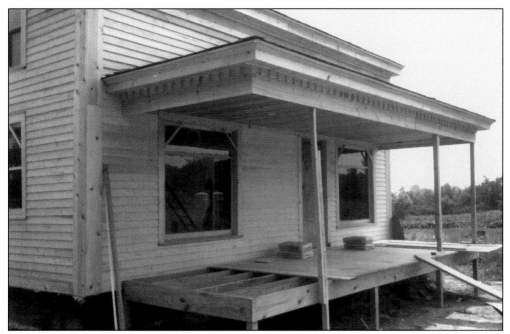

A wood porch was reconstructed to replicate the porch appearing in the 1900 photograph. The two large front windows were very typical of the beginning of the 20th century. Each window had a small rectangular panel of glass (usually stained or beveled) over a very large, clear pane of glass.

Ruth and Vaugh Hinbern are pictured at the opening of the Cranson-Hinbern House on November 22, 1987. An interpretive exhibit of the buildings in the historical village was presented there. The exhibit included photographs of the buildings on their original sites, historic maps, and information relating to the two specific time periods represented in the village. Another exhibit included paintings of Greenmead by Barbara Demgen, a local artist.

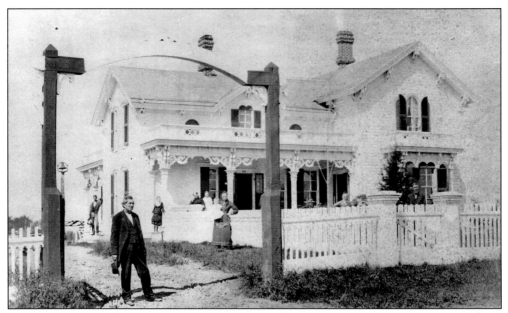

In 1832, at age 15, Alexander Blue moved with his family from Oneida County, New York, to Michigan. His father, Daniel, purchased land for each of his sons. Alexander married Catherine Blue, a cousin, in 1843, and the couple built this two-story farmhouse with many stylish Italianate details around 1855. In addition to being a prosperous farmer, Alexander held several township and county offices and served as justice of the peace for 28 years.

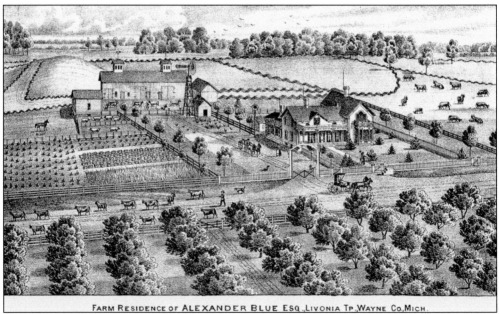

FARM RESIDENCE OF ALEXANDER BLUE ESQ.,LIVONIA TP.,WAYNE CO.,MICH.

Alexander and Catherine had two sons, Malcolm and Daniel, and a daughter, Mary, who died at age 15. According to the census, Malcolm was a deaf mute. Daniel married Luella Briggs, with whom he had two daughters, Mamie and Pearl. Mamie married John H. Patterson, whose farm is now the site of Idle Wyld Golf Course on Five Mile Road. Pearl wed Herman A. Hamilton of St. Joseph, Michigan.

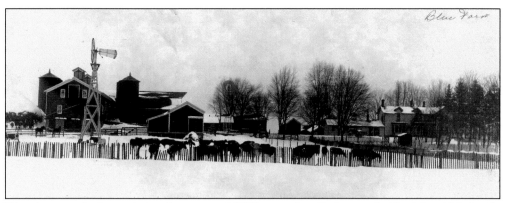

The photograph above, dating from around 1910, was taken facing north. Daniel and his family had always lived with his father and worked the farm. After Alexander died in 1882, Daniel continued to operate the farm. This photograph shows two large barns and several smaller ones, two silos, two windmills, and many small outbuildings. The 300-acre Blue farm was one of the largest and most prosperous in Livonia Township. The photograph below was taken facing south around 1910, most likely by an itinerant photographer. The street in the foreground is Middlebelt Road.

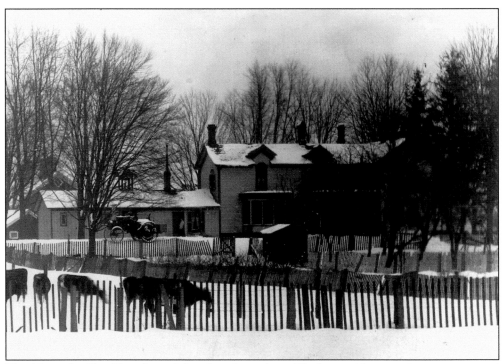

The Alexander Blue House's south facade is shown here. The large addition at the rear contained a bedroom, a cloakroom, and a three-hole latrine. The cupola on the roof may have contained a dinner bell, which would have been pulled from inside. Visible beyond the house are a barn and a smaller outbuilding.

Fred and Frank Wolfram purchased the Blue farm in 1913. Fred's daughter Helen Matavia, pictured above with her son Jimmy around 1955, inherited the property after his death. The Matavias sold some land to a developer in the 1950s and other acreage later on but continued to live in the house until the 1980s. After Helen died, the property was sold with the understanding that the house was to be donated to Greenmead.

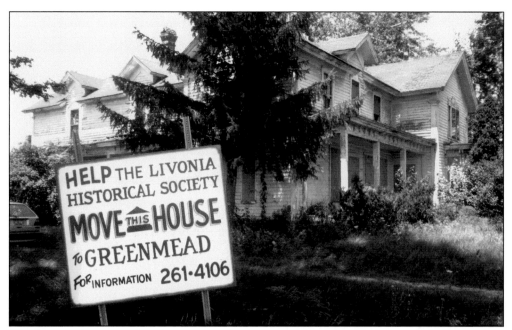

The historical society placed a sign on the lawn appealing for donations to fund the move to Greenmead. The Blue House Committee formed and undertook various activities to raise money: a dance, a movie night, raffles, bingo, a cookbook, road rallies, and a progressive dinner, which proved the most successful fund-raiser. The first dinner raised $6,000, and eventually the group gained sufficient funds. The house was moved to Greenmead in 1987.

One of the initial efforts of Blue House Committee members, pictured here from left to right, Alice Gundersen, George Bisel, and Les Newcomer was to send out a mass mailing to Livonia residents asking for donations.

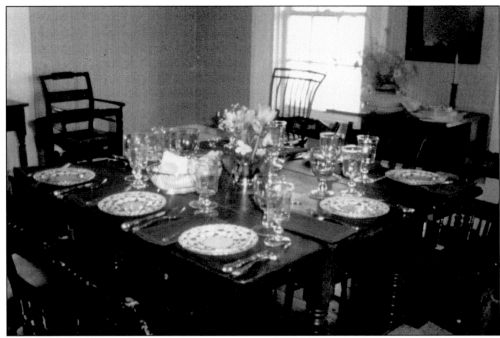

The progressive dinner was such a successful fund-raising event that it was held annually for 10 years. The photograph above shows an elegant table set for soup and salad in the parlor of the Kingsley House. The photograph below shows a later progressive dinner at the Shaw House. The evening's festivities usually started with appetizers at the American House and ended there for dessert. The American House, a retirement residence, was built on the site of the Alexander Blue House after it was moved.

Seen from left to right in the photograph above are Judge Brzezinski of the Livonia 16th District Court, Mayor Robert Bennett, and Alice Gundersen, chairperson of the Blue House Committee. Mayor Bennett and Gundersen presented a plaque to Judge Brzezinski in recognition of the court's donation to the Alexander Blue House.

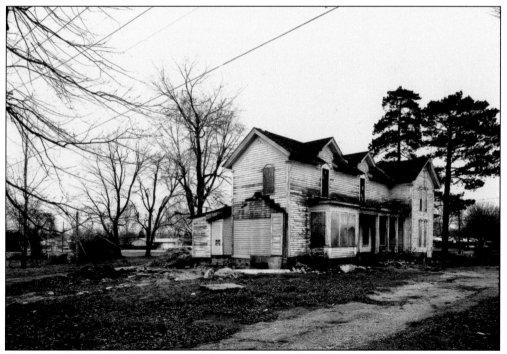

The rear additions have been removed from the Alexander Blue House. Two large trees in front of the house had to be cut down in order for the house to be transported.

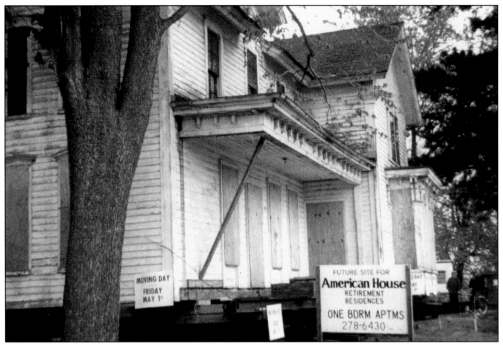

The Alexander Blue House is jacked up and positioned on the skids. The sign states that the site would be the future location of the American House. Also visible is a sign announcing the moving date as May 1, 1987.

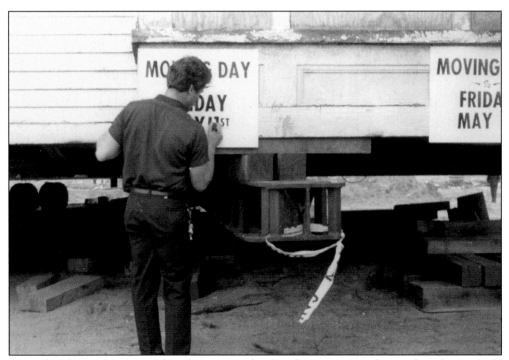

An updated sign announces that the moving date has been postponed several weeks. It would be postponed a second time before the actual move would take place.

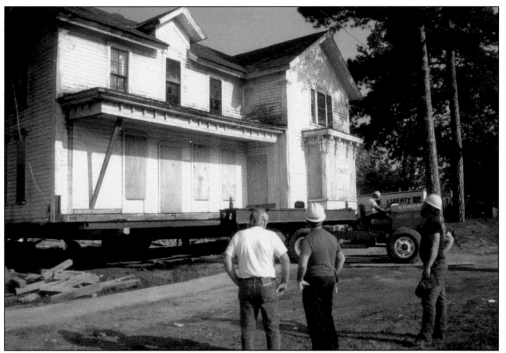

To begin the move, the house was slowly hauled toward the sidewalk. The Alexander Blue House traveled the longest distance of any of the buildings moved to Greenmead. Every detail was carefully planned in order to complete the move in one day and during daylight hours. The movers began preparations about two weeks prior to the move.

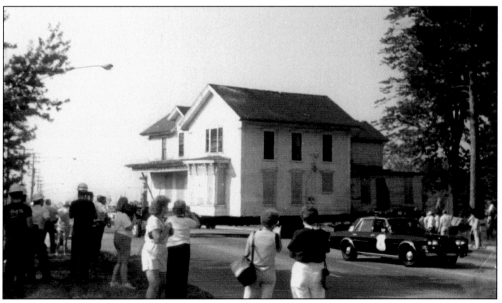

At around nine in the morning on May 26, 1987, the house was pulled gingerly over the curb onto Middlebelt Road. Livonia police provided the advance and rear guard to control pedestrian and vehicular traffic. Utility trucks preceded the house in order to manage the utility lines. Many Livonia residents came to watch the historic event.

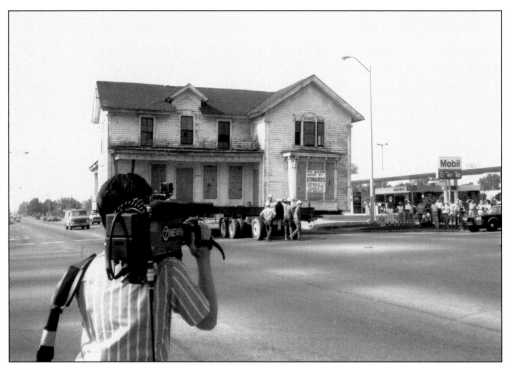

The Alexander Blue House was moved north on Middlebelt Road, occupying most of the width of the street. Channel 7 was just one of the local television news teams recording the big move.

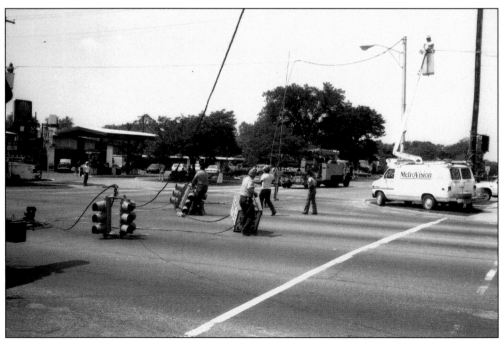

At Six Mile and Middlebelt Roads, the traffic lights were lowered to the ground so the house could turn the corner. An employee of MetroVision Cable TV was hoisted in the bucket, ready to adjust the wires as needed.

Alice Gundersen (left), chairperson of the Blue House Committee, and Suzanne Daniel, chairperson of the Livonia Historical Commission, supervise the long-awaited event. A former Livonia city councilwoman, Gundersen was instrumental in raising the necessary funds to move the Alexander Blue House to Greenmead.

John Colby's students from Cass Elementary School watch the move on Six Mile Road. One of the students at Cass was a descendant of the Wolfram family.

Unexpected problems occurred en route. The radiator of the tractor pulling the Blue House began to overheat, and so the crew had to obtain water frequently along the way to keep the engine cool.

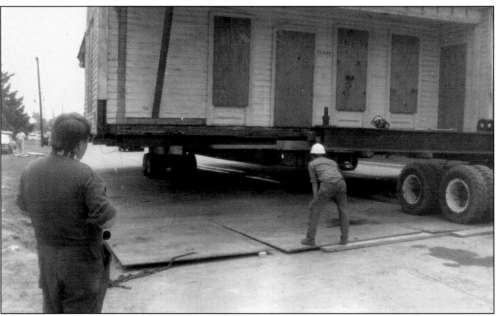

At Newburgh Road north of Seven Mile Road, a second problem was averted. A local builder had excavated a trench across Newburgh Road, unaware of the planned move. A serious glitch was avoided because an alert commission member had double-checked the route early that morning and notified the city of the problem. The city worked with the builder to adequately bridge the trench, allowing the house to pass over it.

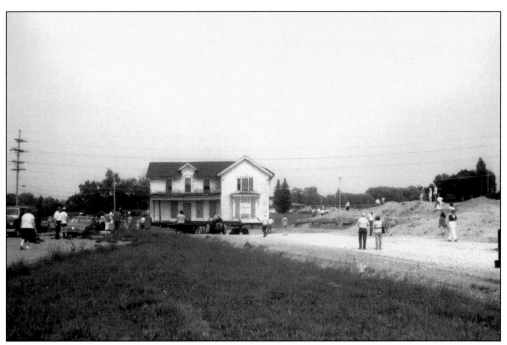

The turn from Newburgh Road onto Joshua Simmons Drive was completed safely. An enthusiastic crowd of people waited to welcome the house to its new location.

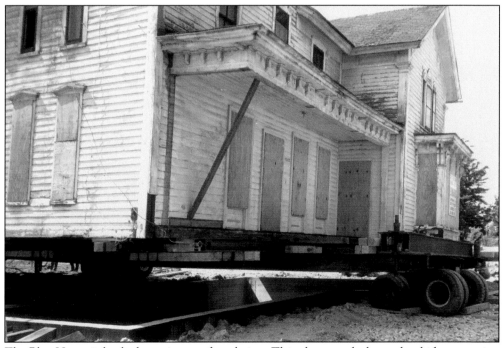

The Blue House is backed over its new foundation. This photograph shows the skids supporting the house. The foundation was poured up to grade level, and then three courses of concrete blocks were added to achieve the correct height. After the mortar cured, the house was lowered onto the foundation.

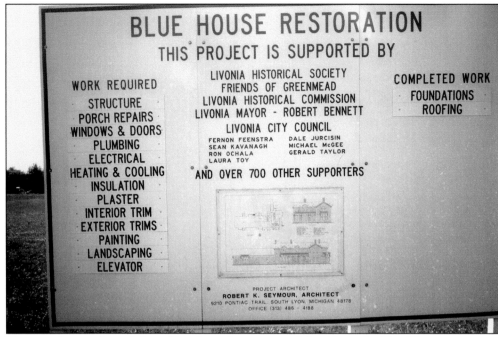

BLUE HOUSE RESTORATION

THIS PROJECT IS SUPPORTED BY

WORK REQUIRED

- STRUCTURE
- PORCH REPAIRS
- WINDOWS & DOORS
- PLUMBING
- ELECTRICAL
- HEATING & COOLING
- INSULATION
- PLASTER
- INTERIOR TRIM
- EXTERIOR TRIMS
- PAINTING
- LANDSCAPING
- ELEVATOR

LIVONIA HISTORICAL SOCIETY
FRIENDS OF GREENMEAD
LIVONIA HISTORICAL COMMISSION
LIVONIA MAYOR - ROBERT BENNETT
LIVONIA CITY COUNCIL

FERNON FEENSTRA DALE JURCISIN
SEAN KAVANAGH MICHAEL McGEE
RON OCHALA GERALD TAYLOR
LAURA TOY

AND OVER 700 OTHER SUPPORTERS

COMPLETED WORK
- FOUNDATIONS
- ROOFING

PROJECT ARCHITECT
ROBERT K. SEYMOUR, ARCHITECT
9210 PONTIAC TRAIL. SOUTH LYON. MICHIGAN 48178
OFFICE (313) 486 - 4188

The sign above informed the public about the progress of the Alexander Blue House restoration and the groups that had participated in raising funds for the project. The photograph below shows the Blue House as it appeared before Phase I restoration work began in 1995. This phase included exterior work such as reconstructing the porches and painting. Interior work included structural and floor reinforcements. The Friends of Greenmead donated $41,000 for this part of the restoration, and the historical society gave $8,000. From the beginning, the Blue House had been planned as an income-producing building and an adaptive use project, whereby a historical structure is adapted for a purpose other than its original use. While the exteriors of such buildings are carefully restored, the interiors may be changed.

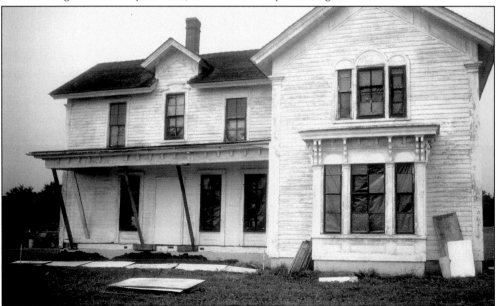

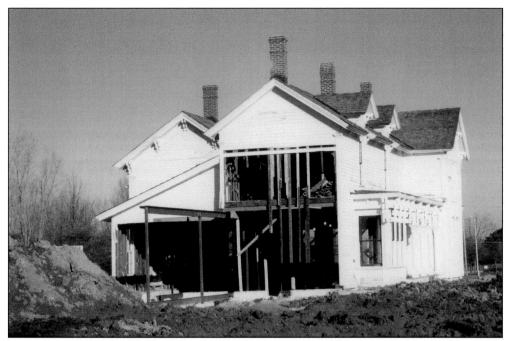

Phase II started in December 2001. In the view above of the house's rear, the back wall has been removed, allowing for the attachment of the new addition. Because the plan for the Blue House involved adaptive use, officials decided to enlarge the structure in order to make it more functional. While the original house had a long, narrow, one-story wing off the rear, a second floor was added to the new expansion (seen below). The addition also allowed for a larger dining area and a kitchen equipped for catered events. The plan approved by the Livonia City Council was to provide a space large enough to seat 100 guests at tables.

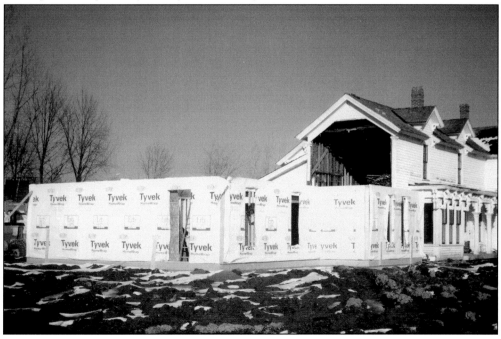

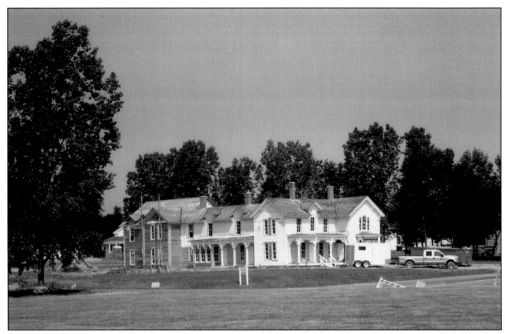

In this view of the Blue House south facade, the exterior of the addition is being sided with wood clapboards. A wood shingle roof is also being applied. Wood shingles were commonly used as a roofing material in the 19th century.

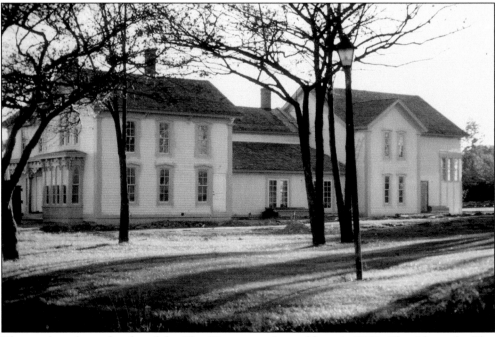

The north and east facades of the Blue House are pictured here in 2002. The Alexander Blue Questers and the historical society raised the funds for replacing the decorative millwork, commonly known as gingerbread. To gain money, the Questers obtained several grants, and both groups sold woven coverlets depicting Livonia historic sites.

The first public use of the building was to host the dinner following Mayor Jack Kirksey's annual golf outing in September 2003. The group enjoyed refreshments outside after its day of golf.

Jan Bennett, the wife of former mayor Robert Bennett, spoke to the Friends of Greenmead at their annual thank-you luncheon. The Friends have raised many thousands of dollars for the Alexander Blue House through activities such as the annual Livonia Christmas walks and the summer garden walks.

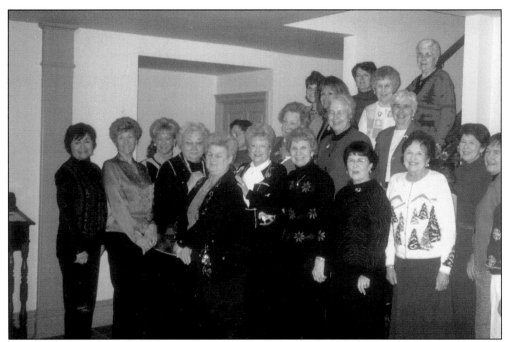

The Friends of Greenmead are shown above in 2003 after their Thank You Luncheon, the first held at the restored Alexander Blue House. The Blue House is seen below in 2005, with its new sign in place. The body of the house is painted creamy beige, the trim is a darker tan, and the window frames, mullions, and doors are mahogany brown. An expert selected this color scheme after analysis of paint chips. It is appropriate to the original time period. The Blue House, which was planned as an income-producing building, is a wonderful venue for wedding receptions, anniversary celebrations, showers, graduation parties, and meetings. These ongoing events will assure that the Alexander Blue House will continue to contribute to Livonia's history and memories well into the future.

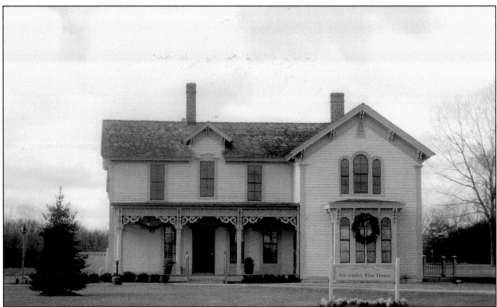

Six

HISTORIC HOMES

The Smith House is located on Seven Mile Road. Ethan Lapham purchased 80 acres of land in 1828 and sold it in 1832 to Lavinia Smith, who most likely was the builder of the house. This upright and wing house, constructed around 1845, has many characteristics of the Greek Revival style. The oldest part of the structure is the northeast section, appearing here on the left. The residence originally consisted of only two rooms.

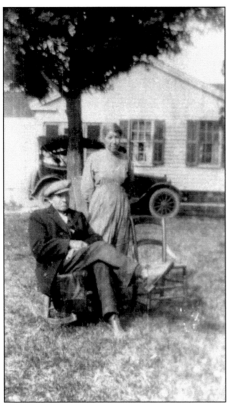

In 1860, Lavinia Smith lived with her son Asa B., who inherited the property after her death. Over time, many additions were made. The earliest was the two-story upright on the west side of the house. This image depicts the Smith House around 1920. The section behind the car is the oldest, while the addition on the left was constructed in the 1920s or 1930s.

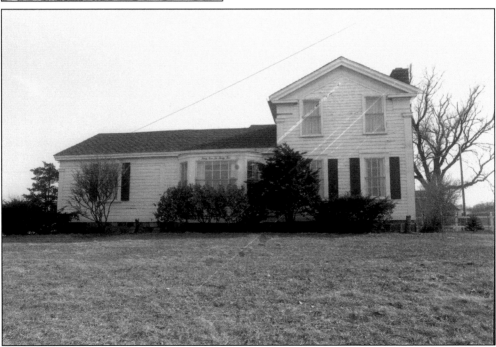

This Smith House photograph was taken around 1950. An earlier Italianate porch has been replaced with a bay window, shown here partially hidden behind the shrubbery.

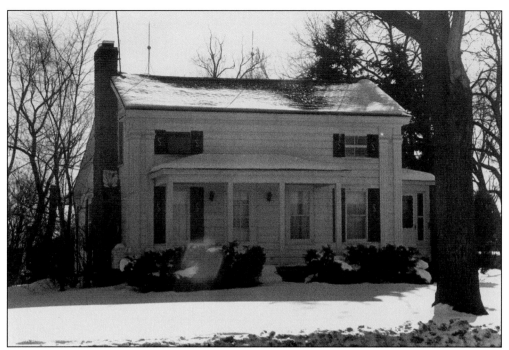

Peter Kator and his wife, Hannah, came to Michigan from New York in 1825 and purchased 160 acres on Seven Mile Road. When Peter died in 1859, his son George acquired the property. This style of Greek Revival home was commonly seen in the 1820–1860 time frame. The porch, shutters, and corner pilasters were probably added in the 1950s. (Photograph by Les Newcomer.)

The Gilt Edge Cheese Factory was located on the Kator property in 1873. Fred Warner, who later became governor of Michigan, purchased the plant in 1907, calling it Warner Factory No. 13. It continued operation under Warner's ownership until the 1920s. The Gilt Edge Post Office was established on the property in 1898 and ran until 1902, when rural free delivery service began.

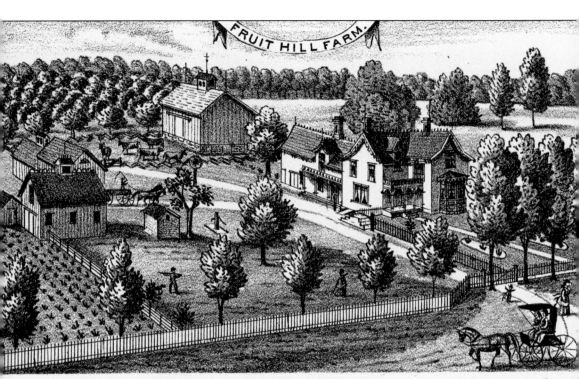

FRUIT HILL FARM.

FARM RESIDENCE OF **MORELL SIMMONS, ESQ;**LIVONIA TP;WAYNE CO.M

Joshua Simmons built this home for his fourth son, Joshua Morrell, on Base Line Road. Joshua Morrell wed Angeline Chillson in 1858, and the house was constructed soon after, most likely around 1866. The couple had five children: Ada Mary, Mattie Emiline, Carrie, Pearl May, and Elza Joshua. The Joshua Morrell Simmons Home displayed many of the characteristics of the Gothic Revival style, including a steeply pitched roofline, flair at the roof edge, vergeboarding (decorative gable trim), and decorative ironwork on the ridgeline of the roof. This stylish residence was built with the intention of impressing all of the neighbors. In addition to the house, Joshua Morrell received 160 acres, which he called Fruit Hill Farm. (Drawing courtesy of the 1876 *Wayne County Atlas*.)

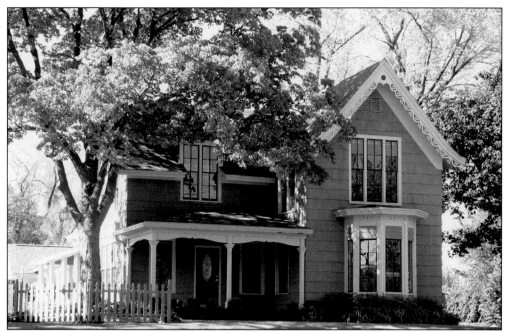

The property remained in the Simmons family through Joshua Morrell's only son, Elza Joshua. The house and the land were separated and sold outside the Simmons family after Elza's death in 1945. The house was adapted for business usage in the 1980s. It was later damaged by fire, but restored. The physician who currently owns the property made a large addition to the rear of the structure around 2003.

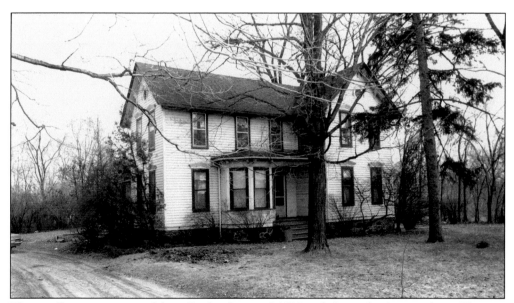

Thomas Bennett emigrated from England around 1834 with his wife, Ann, and son Thomas. They purchased 100 acres in section 33 of Livonia Township in 1849, building this two-story house with Italianate details on Stark Road around 1860. Thomas and Ann had four more children. Following Ann's 1877 death and Thomas's 1880 death, the property remained in the Bennett family through the youngest son, John, until 1915. (Photograph by Electra Stamelos.)

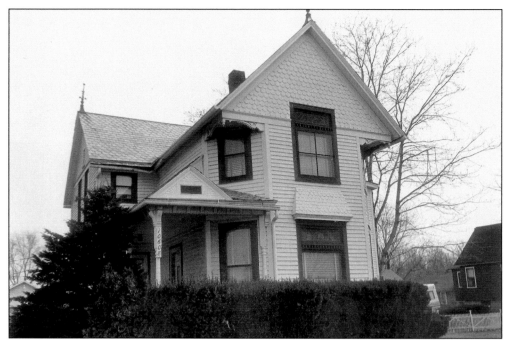

In 1827, Ebenezer Smith purchased 80 acres of land in sections 32 and 33. His first wife, Mary Elizabeth, died in 1844. They had six children; none survived to adulthood. Ebenezer then married Dorothy, and they had seven children. Their son Horace bought the property in 1877, although Ebenezer continued to live there with him. The original part of this house was built on Wayne Road around 1860.

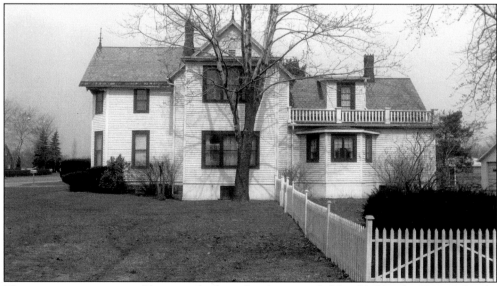

The projecting two-story addition to the front facade was probably added by the Krumm family, who purchased the property in 1894. The front addition was made in the latest fashion—Queen Anne. The Krumm family owned the property until 1934, when it was sold to the Newman Development Company. An addition was made to the south facade of the house in the 1930s, and a kitchen bay was added in the 1940s.

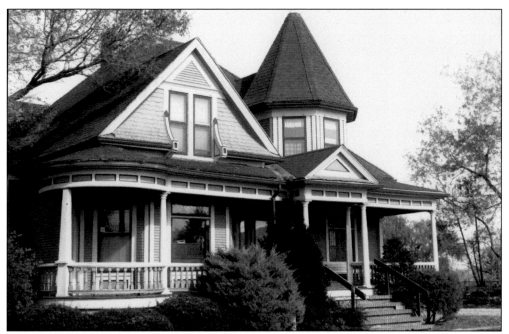

In 1870, 30-year-old Orson Everitt owned 112 acres of land. The grandson of Livonia pioneer Marshall Everitt, Orson constructed this house on his acreage in the late 1880s. The home displays many Queen Anne characteristics, such as irregular massing, a rounded turret with a witch's cap roof, a wraparound front porch with decorative millwork, and a paint scheme of at least three colors and as many as six. Orson still owned the property in 1915. (Photograph by Les Newcomer.)

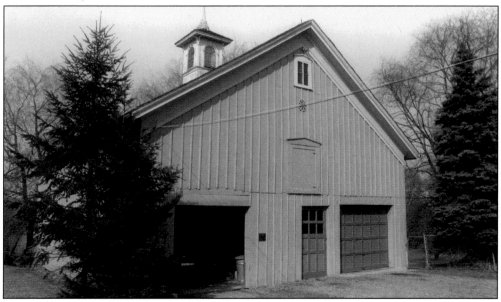

The carriage house was built around the same time as the residence. It was a two-story structure with board and batten siding and a cupola on the roof. It was used not only to hold the carriages and wagons but also to stable the horses. The carriage house was severely damaged in a windstorm in the 1980s and demolished. (Photograph by Electra Stamelos.)

The Orson Everitt House had a fine oak front entry door composed of a single door flanked with partial-height sidelights over paneling. The use of oak was very typical of Queen Anne–style interiors. These interior photographs were taken around 1979.

The law firm of Klein and Bloom purchased the house in 1979 and had it listed on the National Register of Historic Places. The oak stairway and newel post were very typical of the time period. Around 1900, the arts and crafts movement became popular and the Stickley-style furniture, such as the oak grandfather clock, would have been seen in Queen Anne interiors.

Seven

OTHER HISTORIC RESOURCES

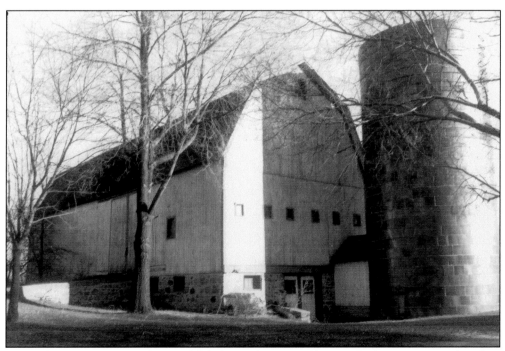

The Wilson Barn is located on Middlebelt Road at West Chicago. Built in 1919, it replaced an 1888 barn that had been destroyed by fire. It was designated a national historic site in 1973. A raised barn, it is built on level ground with an earthen ramp up to the second level. The dimensions are 30 by 80 feet, an average size. (Photograph by Electra Stamelos.)

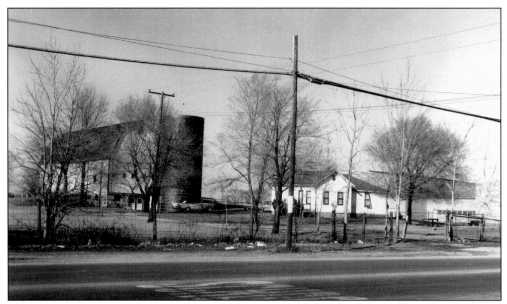

Seen here in 1962 are the Wilson Barn, silo, and original Wilson farmhouse. In 1867, Ira Wilson was born in this house to Sarah and Jeremiah Wilson. In 1888, he wed Mary Hanley, whose family lived across the road. The couple had eight children, but only three—Charles, Asa, and Sarah—survived until adulthood. (Photograph by Nick Mladjan.)

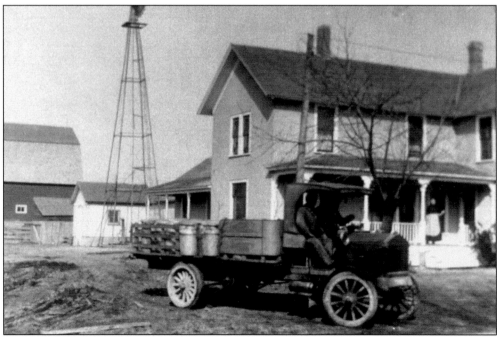

Ira operated a farm on Middlebelt Road north of the railroad. In 1917, he purchased a general store in the village of Elm (south of his farm). His business doubled in the first year; at the same time, he maintained the farm operation. When Ira was seven, he had agreed with a farmer to milk seven cows for seven weeks in exchange for fireworks for the Fourth of July. He later decided that the farmer had driven a hard bargain; he was more alert during subsequent business agreements.

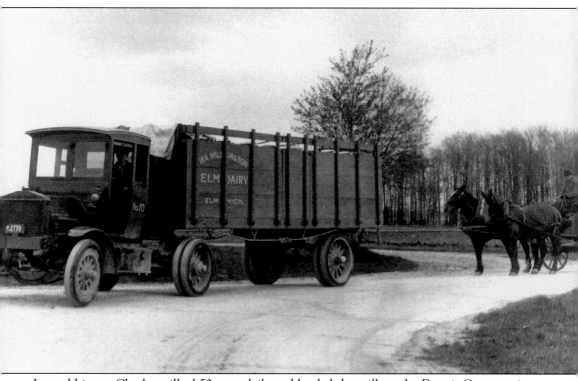

Ira and his son Charles milked 50 cows daily and hauled the milk to the Detroit Creamery in a wagon. Soon they were hauling milk for their neighbors, and in 1915, they purchased a REO truck. They were the first in the Detroit area to adopt this new form of transportation for dairy products. In 1923, Ira and Charles pioneered the use of glass-lined tank trucks to insure the purity of the milk. By 1928, they had expanded their fleet to 75 trucks and 50 large trailers. In June 1930, they organized the Ira Wilson and Sons Dairy, which became the largest independent dairy in Michigan. In the 1930s and 1940s, the Wilson family owned most of the land in sections 25, 26, 35, and 36 of Livonia Township. Charles, Asa, and Ira owned an additional 550 acres in Canton Township.

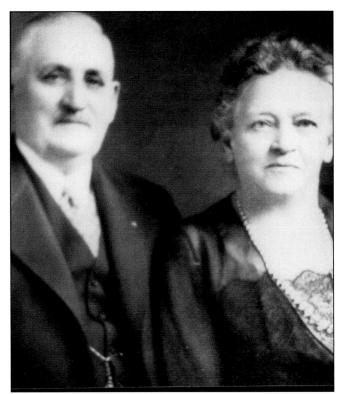

Ira and Mary Wilson pose for a photograph around the time of their 50th anniversary in 1938. In addition to his farming and business activities, Ira was active in Wayne County politics, serving in many capacities. Perhaps the most notable office was sheriff of Wayne County; he served seven terms beginning in 1928.

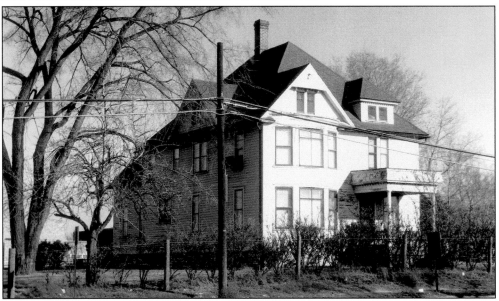

Ira Wilson built this large home for himself and his wife around 1910. The couple's oldest son, Charles, moved into their old farmhouse after his marriage to Carrie E. Place in 1911. Melody Farms purchased the Ira Wilson and Sons Dairy Company in 1980, following the deaths of both Charles and Asa. Livonia acquired the Wilson Barn property by a unique three-way land swap between the bank that had purchased the property, the Livonia School Board, and the City of Livonia.

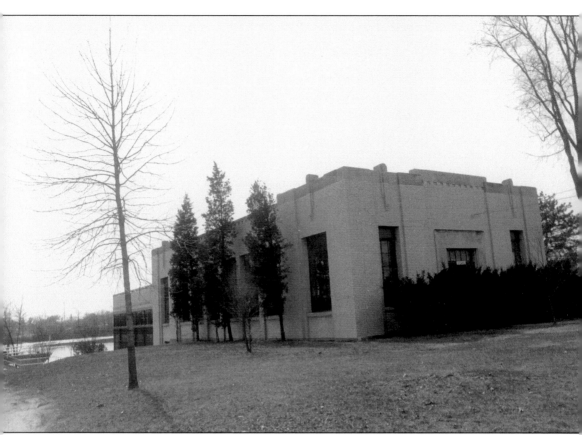

This art deco building was constructed in 1934 as part of Henry Ford's Village Industries program. The Newburg plant was notable because it was air-conditioned, a luxury for an industrial building at the time. Opening in 1935, the plant manufactured 95 percent of the drill bits used by the Ford Motor Company. During World War II, airplane parts were produced there as well. Henry Ford's intent in the Village Industries program was to decentralize the manufacture of automobile parts and set up rural locations to employ local farmers in their slow seasons. There were 22 buildings in all; the first was in Northville, and the last was the Cherry Hill facility, built in 1944 in Canton Township. All the factories were constructed along rivers and utilized water as a source of power. The Newburg Mill property was sold to Wayne County in 1948. (Photograph by Electra Stamelos.)

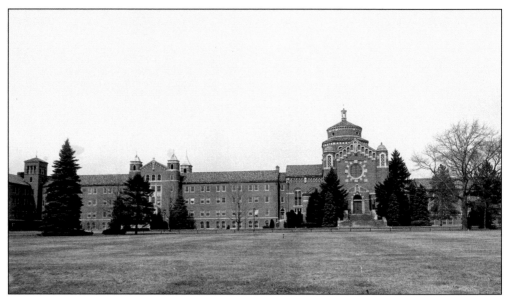

The Felician Sisters, a Catholic women's social service community, was founded in Poland in 1855. The provincial headquarters, originally located in Detroit, was moved to Livonia in the 1930s. The property is the current site of the provincial motherhouse (built in 1936), Madonna University (formerly Presentation Junior College, 1937) Ladywood High School (1950), St. Mary Hospital (1959), and several other facilities.

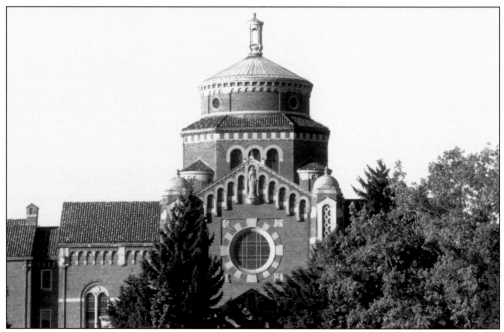

The Villa St. Felix, the formal name of the Felician motherhouse, was built in 1936. The design of this stately open cruciform building is based on the Lombardian architecture of northern Italy. The chapel, which is located directly under the dome, was intentionally designed to be in the center of the building because it is the symbolic center of the sisters' lives. The motherhouse functions as the administrative center for the order.

This structure was originally composed of two separate buildings, the Union Church and Livonia Grange Hall, both located on Farmington Road. The Union Church was built in 1880 and seated 150 people. The Grange hall was moved to this site around 1907 and added to the rear of the church building. The nondenominational church functioned until the 1950s. The entire structure currently serves as Little Tots Nursery School.

The land for the Grange meeting hall was purchased from Nathan B. Kingsley. Established in 1876 with 13 members, the Livonia Grange was active for less than 20 years. The Grange movement began as a response to hard economic times by organizing farmers to act collectively. Eventually the movement evolved into the political arena as well. Grange organizations were also known as the Farmers Alliance and Patrons of Husbandry.

This building, also called Union Church, was constructed in 1850 on Six Mile Road by the Union Society of Livonia, which was chartered by the State of Michigan "to build . . . a house for religious worship and lectures, and all other public uses and purposes." Members of the congregation purchased $5 shares; this money was then used to build the church. Membership dwindled over the years, and the building was boarded up in the late 1930s.

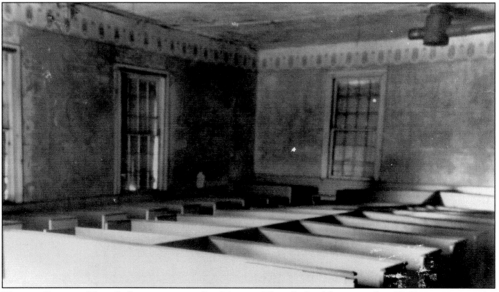

Trinity Baptist Church began using the Union Church building in the 1950s in return for maintaining both the structure and the adjacent cemetery. An addition was constructed on the front and west sides. Stained-glass windows were acquired from a church in Wayne and installed in 1964. The current owner of the building is the Trinity Theater Group, and the historic cemetery is now owned by the City of Livonia.

Eight

HISTORIC CEMETERIES

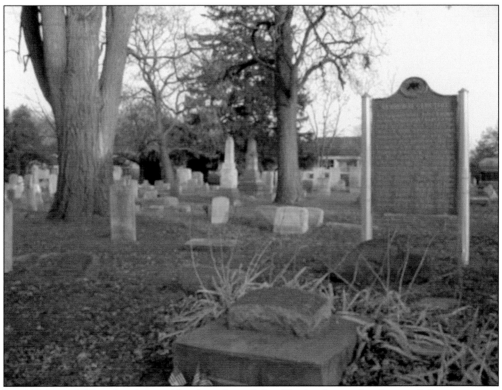

In 1832, Joseph Kingsley donated land on Ann Arbor Trail to be used as Livonia's first cemetery. Joseph's father, Salmon Kingsley, a Revolutionary War veteran, was buried there in 1827. Joseph donated 2.35 acres of land around his father's grave to be used as a community burial ground. It was originally called the Union Burial Ground of Nankin because, at the time, Livonia and Nankin formed one large township. In 1835, the northern half became Livonia Township, and the southern half became Nankin Township. The space is now known as Newburg Cemetery.

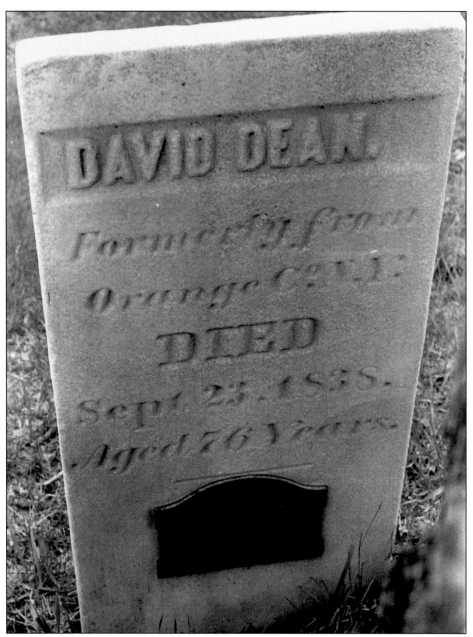

Three Revolutionary War soldiers are buried at Newburg Cemetery. David Dean served in the Revolutionary War from 1778 to 1779, enlisting when he was only 15 years old. He came to Michigan in 1835 with his sons Gabriel, William, and Luther. When David died in 1838, he left his Revolutionary War musket to Gabriel, who left it, in turn, to his son Lafayette. Salmon Kingsley was a member of Kingsley's company in Windham, Connecticut, marching from there in April 1775 for the relief of Boston at the Lexington alarm. He served intermittently during the war until its end. After the conflict, he settled in Vermont and later moved to Michigan, as did several of his children. Kingsley died in 1827. Jeremiah Klumph served from 1781 to 1782 with his father as a courier and teamster in the Quartermaster Corps. In 1836, he moved from New York to Livonia Township to live with his son Nelson. Jeremiah was Ira Wilson's grandfather.

The Grand Army of the Republic dedicated a monument in Newburg Cemetery to Civil War veterans in 1901. The Elmwood Questers funded the restoration of the monument. Over 50 Civil War veterans are buried at Newburg Cemetery, including John and Alfred Ryder, who both died at Gettysburg. John served in the Michigan 24th (Iron Brigade), while Alfred was a member of the 1st Michigan Cavalry.

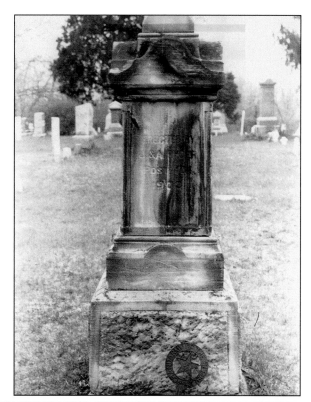

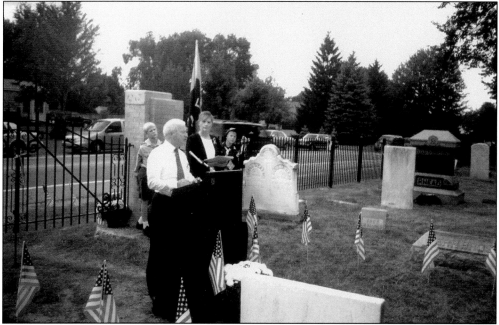

Mayor Jack Kirksey speaks at the dedication of the restored fence and gate in September 1997. The Elmwood Questers financed the Newburg Cemetery project, one of several cemetery restorations funded by the chapter. At the ceremony, Boy Scouts and Cub Scouts served as flag bearers and honor guards.

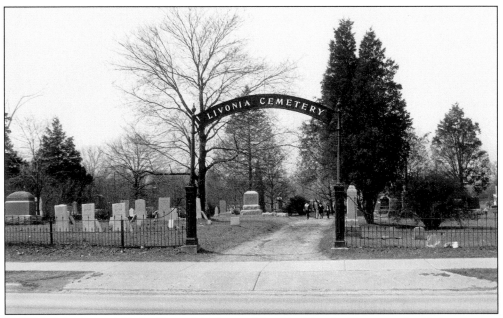

In 1836, Ephraim and Phebe Butterfield donated land in Livonia Center to the Union Society for the creation of Livonia Cemetery. This is the burial site for members of many of Livonia's pioneer families, such as the Chillson, Brigham, Gates, Kingsley, Smith, Johnson, McKinney, and Hawkins families. The veterans of five wars also rest in Livonia Cemetery.

Emily Maltby was the adopted daughter of Ann Shaw Briggs. When Emily's mother died, local families adopted all of the children. Emily's brother Frederick, who was raised by the Warner family of Farmington, later became governor of Michigan. Emily's sister Clare was adopted by Reul Durfee, whose wife, Mercy Ann, was a member of the Briggs family.

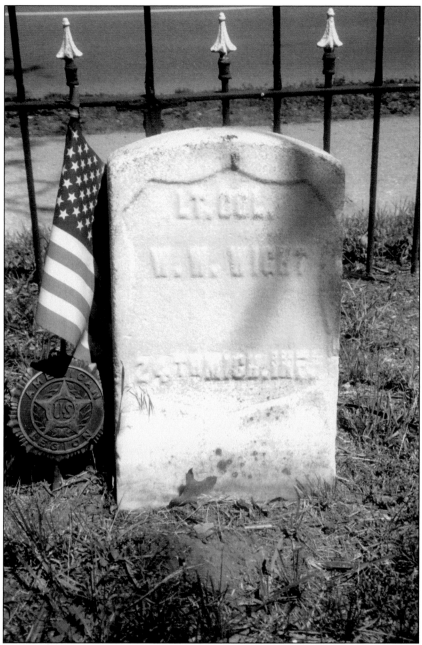

This is the headstone of Lt. Col. William W. Wight, Company K of the Michigan 24th. Enlisting on July 26, 1862, with the rank of captain, Wight was one of the original members of the 24th and the highest-ranking officer from Livonia to serve in the Civil War. He and his company saw action at Fredericksburg, Fitzhugh's Crossing, Chancellorsville, Gettysburg, and the Wilderness. His son Wallace W. Wight, also of Company K, was killed at Fredericksburg. Wounded at Gettysburg and the Wilderness, Wight resigned due to disability on June 9, 1864, with the rank of lieutenant colonel. The Michigan 24th, which included 31 other Livonia men, was the regiment about which Abraham Lincoln made the statement, "Thank God for Michigan." The 24th also performed honor guard duty at Lincoln's funeral in Springfield, Illinois.

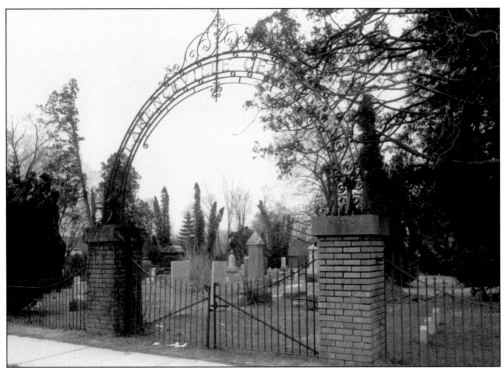

Clarenceville Cemetery, organized in 1841, is located on Base Line Road. It was managed by the Union Burial Society, which met once a year in April. The cemetery contains the burial sites of soldiers from four conflicts, including the Revolutionary War. Clarenceville was one of several small crossroads villages, along with Newburg, Stark, Elm, and Livonia Center.

Over time, many of the headstones in historic cemeteries are damaged by the natural processes of aging, such as erosion of the stone by weather, algae, and also pollution. However, some of the damage is caused by human activities like vandalism and lawn mowing. In the late 1980s, the Historic Preservation Commission funded the repair and restoration of many headstones at Clarenceville and Newburg Cemeteries.

Benjamin Walker Grace served in the New Hampshire Militia in the Revolutionary War from 1780 to 1783. He married Rachel Patton and moved to Maine, where the couple's 11 children were born. The Graces then moved to Lyons, New York, sometime before 1818. About 10 years later, the Graces moved to Michigan to live with their children in Farmington Township. Benjamin Grace died in 1851 at the age of 91.

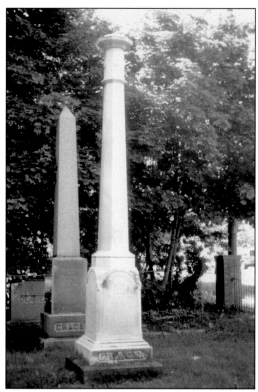

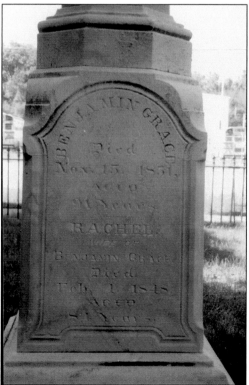

Shown here is the inscription on Benjamin and Rachel's headstone. Their daughter Hannah Patton Grace was the mother of Mary Grace Lambert Kingsley. Mary Grace married Nathan B. Kingsley, the builder of the Kingsley House, which is now located at Greenmead. Six of the Graces' 11 children lived in the Livonia/Farmington area. Their daughter Sally married Stephen Jennings, who built the Botsford Inn in 1835.

Dr. William M. Shaw was born in Londonderry, Ireland, in 1800. He graduated from the University of Edinburgh, Scotland, with a diploma as a physician and surgeon. In 1821, Dr. Shaw immigrated to Fort Plain, New York. He married Leah Borden in 1826, and they had five children: Mary, Elizabeth Malvina, Sarah Jane, Martha Adelia, and William Clay. While living in New York, Dr. Shaw supervised the building of the locks on the Erie Canal. Sometime after 1842, the Shaws moved farther west to Livonia Township. Dr. Shaw farmed his property and practiced medicine in Livonia for many years. He died in 1885.

Union Cemetery, often referred to as Briggs Cemetery, was founded in 1850 on land donated by Luther Briggs and the Stanton family, whose properties adjoined one another on Six Mile Road. The Union Church and Union Cemetery constituted one property until being divided in 2004. The title to the church building was given to the Trinity Theater Group, while the City of Livonia retained ownership of the historic cemetery.

Paul W. Hazen served in Clark's New York Militia in the War of 1812. He was born to Edward and Mercy Hazen in 1793 and died in 1878 in Plymouth Township. Paul owned 60 acres in Plymouth Township's section 13 in 1860. By 1876, he had increased his land holdings to 80 acres located about a mile west of Union Cemetery.

117

Many members of the Briggs family are buried in Union Cemetery because they lived nearby. Carmi and Louis Briggs had farms on opposite sides of Six Mile Road, east of their brother Luther's farm. Dexter owned the land at the corner of Seven Mile and Newburg Roads. Another brother, John, lived farther east on Middlebelt Road. Three of Luther's children died in childhood and are buried near the family marker.

Caroline (Carrie) Moreland Riddle, who died in 1962, was one of the last burials in Union Cemetery. Carrie's parents, William and Francis, settled in Livonia around 1860 on 80 acres of land west of Luther Briggs's property. Both William and Francis were born in New York. Carrie inherited the farm after her father's death in 1902. Their former land is now the site of the Laurel Park Shopping Center.

Nine

LOST HISTORIC BUILDINGS

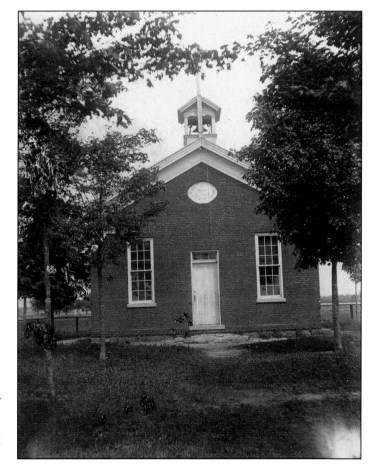

The authors have defined three categories of lost properties: buildings that have been demolished, buildings that have been moved out of Livonia, and buildings that have lost all of their defining features. The Briggs School (School District No. 3) was built in 1859 on Six Mile Road at Newburg. It was still in use when the districts were consolidated in 1944. When the Newburgh Shopping Plaza was built in 1964, the Briggs School was demolished.

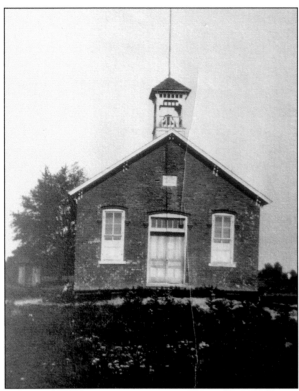

Livonia Center School (School District No. 4) was built in 1872 on Farmington Road south of Five Mile Road. It was demolished in 1927 to build a four-room school on the site. The population of Livonia doubled between 1920 and 1930 and continued to double every decade until the 1950s, when it exploded. The present school board office building was constructed in front of the four-room school. There is now a connector between the two buildings.

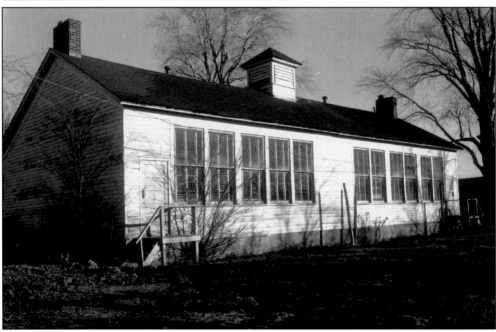

Located on Middlebelt Road south of the railroad tracks, the Elm School (School District No. 6) was constructed by the Wilson brothers in 1869 and enlarged in the 1920s. A two-room brick school was built in the 1930s and expanded a few years later. Both Elm Schools were demolished in the 1970s to make way for the construction of what is now the GM Powertrain plant.

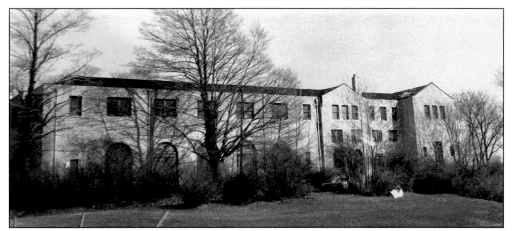

Northville Golf Club, also called Northville Country Club, was built in 1923 on Newburg Road at Seven Mile Road. Local legend holds that the clubhouse was a frequent haunt of the infamous Detroit Purple Gang. Violet E. Morris purchased the property in 1946 and renamed it the Northville Golf Course. The building was demolished in the 1980s, and the Providence/St. Joseph Mercy health facility is now located on the site. (Photograph by Electra Stamelos.)

The clubhouse hosted dances every Friday and Saturday night, featuring popular orchestras with singers such as Danny Thomas and Betty Hutton. The space was also used for private parties such as the Pi Phi preconvention party in 1937. The clubhouse had a large ballroom with French doors on both the east and west sides. The doors could be opened in the summer to catch the cooling breezes.

The Old Dutch Mill was located on Five Mile Road between Inkster and Henry Ruff Roads. Owned by George and Clyde Bentley, the mill sold farm implements and eggs. It was built in 1924 and demolished in the late 1950s or early 1960s.

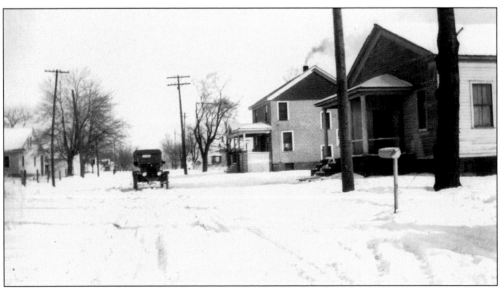

The building on the right was the original Newburg Methodist Church, built in 1846 and located on Newburg Road north of Ann Arbor Trail. After the Methodist congregation moved into the former Presbyterian/Congregationalist church on Ann Arbor Trail across from Newburg Cemetery, this building was moved south of Ann Arbor Trail and became the Ladies Aide Society Hall. The hall was used until the 1940s, when it was demolished.

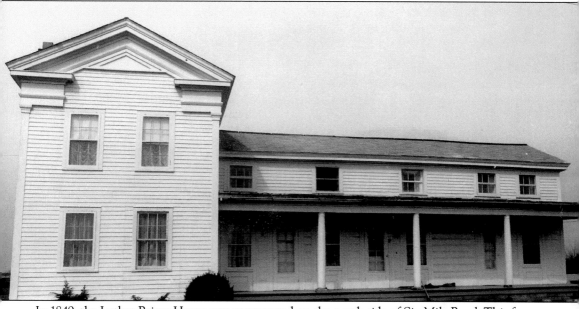

In 1849, the Luther Briggs House was constructed on the north side of Six Mile Road. This fine upright and wing Greek Revival house, containing 12 rooms, included an atypical elongated wing with three entry doors. Luther was one of six Briggs brothers who emigrated from New York to Livonia Township. His daughter married Judge Alexander Blue's son Daniel. In 1973, the house was purchased by Trinity Baptist Church and moved from the path of Interstate 275. One of the ministers of the church lived in the home and did a great deal of interior restoration after the move. When the church sold the property to a developer, the house was severely vandalized. It was demolished in 1997, after it was unsuccessfully offered free to anyone who would transport it from the site. (Photograph by Electra Stamelos.)

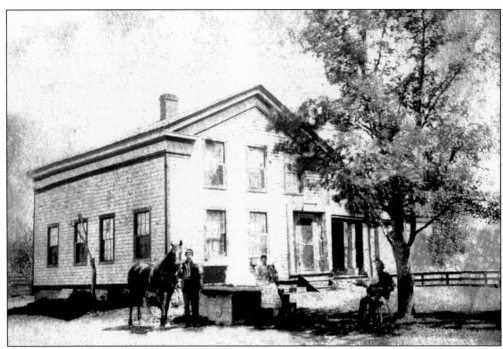

This gable front and wing Greek Revival house, built by George and Henrietta Ryder in 1856, was located on Plymouth Road east of Levan Road. The Ryder family farmed 160 acres and had eight children. George came to Michigan from eastern New York with his parents, David and Polly Ryder, in 1827. He and Henrietta were the parents of Alfred and John Ryder, who were killed at Gettysburg during the Civil War.

The Ryder home is pictured in the early 1900s. The one-and-a-half-story wing has been raised to a full two stories, the porch on the wing extended across the front of the gable section, and the windows altered. In the early 1950s, the house was moved to Nankin Township, south of Warren Road. The Ford transmission plant was constructed in 1952 on the former Ryder property.

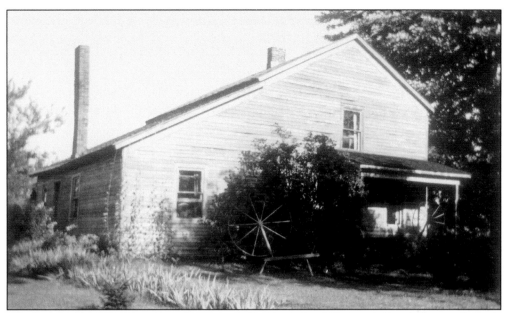

The Frazier-Clemens House stood on Levan Road south of Plymouth Road. Originally built around 1840, the house went through multiple changes over the years. In 1826, Martin Frazier purchased 80 acres, which he owned until at least 1876. The Rosenburg family then owned the land until 1917, when it was purchased by Levi and Isabella Clemens. They built a larger home next door and extensively remodeled the older house in the 1940s.

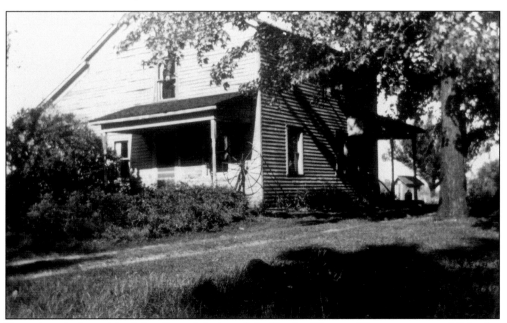

Even though the original details and design of the Frazier-Clemens House were not visible, the age of the structure was determined by construction features such as the hand-hewn logs with bark still intact, the extremely steep stairway with shallow tread, the very low ceiling (six and a half feet) on the second story, the hand-wrought square-headed iron nails, and the horsehair binder in the plaster. The home was demolished in the 1990s.

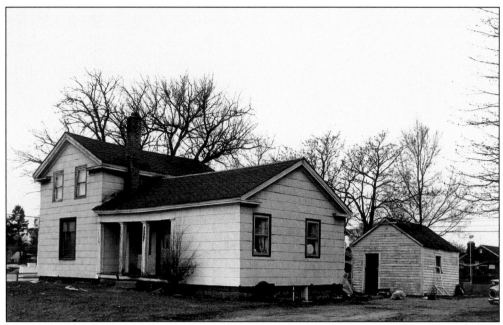

The Samuel McKinney House was located on Merriman Road north of Plymouth Road. This modest Greek Revival home was demolished in 1975, and a Taco Bell now occupies the site. The McKinneys first settled in Redford Township, then moved farther west to Livonia Township. At one time, Merriman Road was known as McKinney Road.

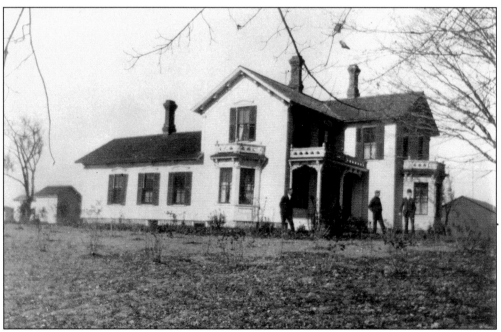

The Pankow-Hosback House stood on Middlebelt Road south of Five Mile Road. This large Italianate home had two bay windows, brackets under the eaves, Italianate porch columns, low balustrades above the porch and both bays, and a paint scheme that outlined the detailing. The Hosbacks owned the farm from 1913 to 1920, and this photograph dates from that time period.

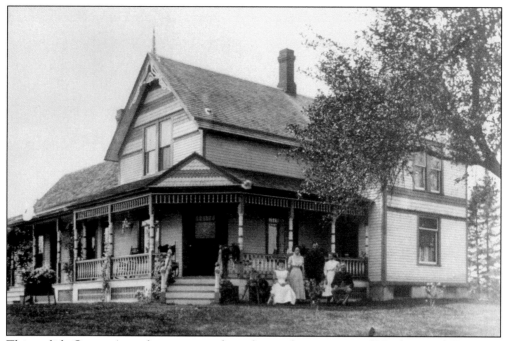

This stylish Queen Anne home, situated on the southeast corner of Newburg and Five Mile Roads, was built around 1890 by C. Wolf. It had typical Queen Anne detailing such as decorative bicolored shingles in the gables, a wraparound porch with spindles in the balustrade and frieze, a multicolored paint scheme, and a Queen Anne sash in the large window. The house was demolished, and the property is currently owned by the Felician Sisters.

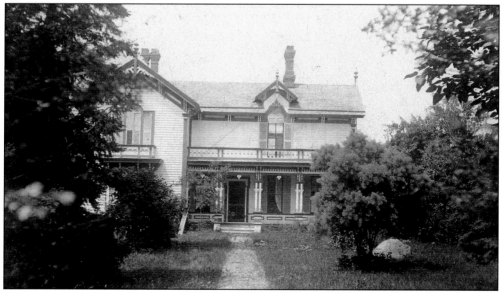

The story of the Carmi Briggs and Ann Shaw Briggs House makes a good ending for this book. Most of the detailing of this fine Italianate home had been lost over the years. In addition, the bay window had been completely removed, including the foundation. However, the house is now enjoying a resurrection. The current owners are gradually restoring the lost features using this photograph as a guide.

DISCOVER THOUSANDS OF LOCAL HISTORY BOOKS
FEATURING MILLIONS OF VINTAGE IMAGES

Arcadia Publishing, the leading local history publisher in the United States, is committed to making history accessible and meaningful through publishing books that celebrate and preserve the heritage of America's people and places.

Find more books like this at
www.arcadiapublishing.com

Search for your hometown history, your old stomping grounds, and even your favorite sports team.

Consistent with our mission to preserve history on a local level, this book was printed in South Carolina on American-made paper and manufactured entirely in the United States. Products carrying the accredited Forest Stewardship Council (FSC) label are printed on 100 percent FSC-certified paper.

MADE IN THE
USA